WINDOWS INTO HEAVEN

Stories Celebrating Down Syndrome

Stacy and Michelle Tetschner

Published in the United States by Stacy and Michelle Tetschner

For more information or to order additional copies of this book visit www.windowsintoheaven.net.

Library of Congress Cataloging-in-Publication Data
Windows Into Heaven – Stories Celebrating Down Syndrome
/Stacy and Michelle Tetschner

ISBN-13: 978-0-615-22123-6

TABLE OF CONTENTS

INTRODUCTION

A Window into Heaven

By Michelle and Stacy Tetschner

After 12 years of marriage, we were living a blessed life with two happy, healthy sons. We weren't planning on expanding our family, either naturally or through adoption, at this time. But fate intervened, and we became aware of a baby girl who needed some loving care. Her parents were experiencing a series of struggles, forcing them to send her to live with relatives who were no longer able to care for her. We could not bear to see this beautiful baby go into the foster care system, so we agreed to take her into our home.

Within six weeks, the baby's parents worked out their problems and she returned home. Her departure left an emotional void that prompted us to become a licensed foster family. We looked forward to providing a home filled with love for children who needed extra help.

Over the next nine months, we attended classes and learned about things that should never happen to children and yet they do. Our home was scrutinized and inspected to ensure a safe environment for any child who came to

live with us. We educated ourselves about potential challenges. It was not an easy process. Occasionally, we would ask ourselves if it was really worth it. Instinctively, however, we knew becoming licensed foster parents was our calling and we focused on fulfilling the requirements.

At the same time, there was another little soul who was facing his own challenges. His mother had faced many obstacles throughout her life that prevented her from being the best mom she could be to the children she already had. Four weeks before her due date, she delivered a five-pound boy who added another challenge to her complicated life: He had Down syndrome.

Back at our home, our family was ready and excited to provide a loving home for a child in need, whether it was for a few days or a few months. And here was a child who desperately needed love, support and a safe place to call home while his uncertain future began to unfold. Soon, our paths would cross.

Our lives synchronized one Tuesday morning when Michelle was grocery shopping. She received a call from Melissa, our foster placement worker who asked if we were ready for our first placement. Melissa described a five-day-old Native American boy who had Down syndrome and needed an emergency placement for two to three weeks. A few days earlier, his mother left the hospital without him. Michelle jotted down all the details about this baby boy and, after talking to Melissa, she called me about helping this little boy for the next two to three weeks.

When Michelle was pregnant with our biological

children, we discussed Down syndrome and how to prepare for it; however, our foster parenting classes did not cover special needs training. Nonetheless, we felt we could meet this challenge and provide a loving home for this baby until an adoptive family was found. At 10:30 a.m., Michelle called Melissa back to let her know we agreed to take him into our home. Melissa informed us that we needed to pick up the baby from the hospital at 1 p.m.! That gave us less than three hours to prepare for what we took nine months to do the last time. Michelle made a quick u-turn from the checkout line and went back to the baby department to load up on all the necessary supplies.

Giving birth to your own child and taking him or her home from the hospital is an amazing experience, but going to the hospital to pick up another infant is surreal. After finding the hospital's NICU ward, we were introduced to a little peanut of a baby named Raymond, who weighed barely five pounds. He had jet black hair and the face of an angel.

The nurses were just completing his medical tests, and it seemed we should be ready to leave soon. The discharge process seemed to drag and after 90 minutes, we finally asked the nurse how soon we would be able to take Raymond home. Curtly, she replied, "I will let you take *my* baby when I am ready."

Later, we later learned this nurse had been working 12-hour shifts for three days straight since Raymond's birth. She had become very protective of this little boy, who was abandoned by his mother. Amazingly, Raymond was touching lives and hearts at barely five days old. We

left an hour later with Raymond after receiving very detailed instructions regarding his care.

The next three weeks stretched into months as the state of Arizona worked through various processes and steps to legally prepare Raymond for adoption. There were court cases and appearances, visits from a variety of people, and a mountain of i's to dot and t's to cross. We did not mind the red tap, as our entire family adored Raymond right from the start.

As Raymond grew and became more aware of his surroundings, we noticed his special gift. He could sense when people needed some attention. A visit to the grocery store with him in the cart sparked at least one or two random hugs for a cashier or another customer. Frequently, they responded by remarking how much they needed a hug that day and some would even tear up. Raymond became a little window into heaven for many people everywhere we went.

The three-week placement turned into seven months before Raymond was ready to be placed for adoption. When the social worker assigned to his case phoned to introduce herself, she immediately asked Michelle, "So, what's *wrong* with this baby anyway?"

Although our family tried to maintain some distance in our relationship with Raymond because we wanted to minimize our heartbreak when he left us, Michelle was infuriated by the social worker's tactless and heartless question, and she did not mince any words telling her that Raymond was perfect just as God had made him. After Michelle's long-winded response, the social worker paused

and asked in the kindest voice, "Then why aren't you adopting him?"

In my profession, I have worked with many outstanding salespeople and sales trainers and this is, by far, the best sales technique I had ever heard. We had not considered adoption believing that "God had placed him with us for a little while until the right family who needed him was identified." Soon, our own family realized that we needed him. When we told our two boys that we were the right family for Raymond, they said, "Well duh, we already knew that; it just took you two longer to figure it out."

On National Adoption Day 2003, Raymond became a permanent part of our family. We celebrated with almost a hundred people in our back yard, all of whom supported us through this entire process and can tell you that Raymond has shown them a window into heaven. Raymond, wearing a tuxedo, hammed it up all day long. By having Raymond in our family, we have been introduced to incredible people who inspired us to write this book and share a small sample of inspirational stories revealing how children and adults with Down syndrome are positively changing lives every day.

The title, *A Window into Heaven,* has special meaning. When Glenna Salsbury, a professional speaker from Paradise Valley, Ariz., addressed our Sharing Down Syndrome Arizona group in January 2004, she shared some compelling information about a belief held by a number of Native American tribes. Through their sheer simplicity, children with Down syndrome are a window to the Great Spirit.

We translated that belief into a title for our book because we feel these children are truly a window into heaven. Whether you are a parent of a child with Down syndrome, are blessed to know someone with Down syndrome, or are just looking for some amazing and inspiring stories, we hope you will look through these windows for a glimpse of the heaven that so many of us already know.

Stacy and Michelle reside in Mesa, Arizona with their three boys. They wish to thank each of those incredible parents and advocates who have created so many wonderful opportunities for those who are blessed to have Down syndrome; and it is truly a privilege to share some of their stories. These children and adults are truly angels and teach us something every day if we take the time to listen.

IAN FISHER: THE BEST TEACHER I EVER HAD

By Danielle Fisher

At age 23, I was thrilled to be expecting my second child. Seth, my first born, was a Godsend and absolutely perfect. Being young and naïve, I expected my second child to be perfect, too, and he was—perfect with Down syndrome. My husband and I were told that Ian, born eight weeks early, might have Down syndrome. At first, we struggled with the devastating thought of having a child with Down syndrome. And then, we decided that it might not be so devastating.

We brought Ian home seven weeks after he was born and we were in love. We met with doctors, specialists and all kinds of therapists. I was not going to let anything stop Ian. I wanted him to succeed at everything. We fought to get specialists, extra therapy and this and that. I hadn't a clue how much Ian was teaching me.

One day, it dawned on me that I hadn't slept a full night in over a year, my hair hadn't been trimmed in six months, and I couldn't remember the last time I had a bubble bath. I realized how much those things didn't matter to me. I had never felt so selfless, and I loved it. I had finally become the

type of mother I always wanted to be: a mother who gives every bit of herself to her children. This epiphany was the tip of the proverbial iceberg.

As Ian grew bigger and stronger, I watched him overcome struggle after struggle. I was in awe of his strength the first time he signed something to me, the first mumble of "momma," and the first time he crawled. Sometimes, when I think I have so much going on that I "can't" do this, I stop and think about Ian. This little boy has looked adversity in the face and overcome it. I've never said, "I can't handle all of this." I just stop and think, "Look what Ian has to deal with." He has taught me so many wonderful things about myself and what children with Down syndrome can overcome. In fact, Ian has taught me more in the past four years as his mother than I have learned in the first 23 years of my life. I also have been blessed to know other people with Down's and they, too, have taught me about the important tools needed to get through life.

Ian resides in Kansas with his mother, father and older brother, Seth. Ian is a blissfully happy, beautiful, yet ornery child. He is the delight of his family, and all who know him. Danielle, Ian's mother, can be contacted at danifishi@yahoo.com.

DIAMONDS IN THE ROUGH:
LESSONS FROM BASEBALL

By Amy Burton Moore

It's a sure sign of spring when little league baseball schedules for my three sons start filling the family calendar. Each afternoon, as we join other parents on the sidelines with our awkward assortment of folding camp chairs, blankets and coolers, we wonder, "Will we lose today?"

But it's not the game I'm worried about. What I really mean is, "Will we lose track of Kenly today?"

Kenly, age 11, has no interest in baseball. She's far more interested in dolls, dancing and dress-ups than in dust, dirt and dugouts. Attending games, however, gives her the opportunity to perform rambunctious, embarrassing cheers that send each of her brothers into the dugout to hide in humiliation, especially if she has chosen her own outfit that day: pink shorts and tank top if it's stormy outside, and pink hat, pink sweater, pink gloves and pink scarf if it's nearing 100 degrees. Oh, did I mention that Kenly likes pink? But we vividly recall one particular day when we all would have taken any article of clothing over the alternative.

Lesson #1: Not everyone enjoys baseball, so keep an eye on your kids.

On Memorial Day three years ago, as we sat watching two little T-ball-aged sons scrambling after a ball with their pint-sized teammates, Kenly ran over to a nearby playground. The sun was beating down, making it difficult to see either the action (or lack thereof) on the field, or the action on the playground. And soon Kenly was missing. But we didn't know this until several neighbor kids approached us with a teenage lifeguard from the community pool in tow. The lifeguard asked if I happened to be Mrs. Moore. Although something inside begged me to deny being this person (a negligent, untrained baby sitter or distracted aunt sounded less culpable), I nodded. He assured me my daughter was fine, and asked me to follow him back to the pool. Apparently, Kenly had blended in with another family to enter the facilities, disrobed and jumped into the cool, refreshing waters. Had she not been a tall eight-year-old with Down syndrome—and *naked*—she might have drowned. Luckily, she stuck out like a sore thumb or, at least, a pruned, water-wrinkled one.

Lesson #2: If you have a child with Down syndrome, you have an instant family wherever you go, and as families we look out for and befriend one another.

Two years later, we were still wary about Kenly's escapist tendencies, and kept a vigilant watch over her

during baseball games. One afternoon, I witnessed a little redheaded boy approach Kenly and ask, "Wanna play?"

No matter how much I wish it did, this scenario does not occur often. Kenly's behaviors often tend to repel rather than attract potential friends. But as I watched the overture of friendship, I perceived it was genuine. And off they scampered. Of course I couldn't find Kenly at the end of the game, and as I walked around calling her name, a man approached me and asked, "Are you Kenly's mother?"

Thinking back to the skinny-dipping incident of 2004, I was prepared to dash over to the pool until I saw the tiny blondie he cradled in his arms—an adorable child with Down syndrome. This man also was the father of the redheaded boy who had befriended Kenly. I chatted with him and his wife like we were old friends as Kenly reappeared with their young son from the playground.

Lesson # 3: As in baseball, it pays to keep your cool in the game of life, because potential enemies are also potential allies.

Another time we attended a frustrating all-star game at an unfamiliar ballpark. Kenly, dressed in her usual fluorescent pink (much for my benefit), hung out with anyone who she was not related to and happened to have snacks. After the game we packed up the trusty camping chairs and started heading back to the minivan when two of my sons came running up to me, breathless.

"Mom!" they gasped. "Some boys were mean to Kenly! They were calling her deaf and blind and *stupid*!"

5

The heat of the day, paired with the frustrations of the game and an adrenalin-surging fight among some of the more boisterous parents, made this news particularly irksome to me. I stormed off across the park with my pulse racing to give these bullies a scathing piece of my maternal mind.

"Which boys?" I growled, my eyes narrowing. My sons pointed to a group on a grassy hill. "Let's go talk to them," I said as we stomped our way to the hill. As we approached, the bullies noticed my expression and suddenly looked terrified. But I didn't yell at them as I had intended because on the way over the rational side of my brain reminded me this could be an available teaching opportunity as to how these boys would view Down syndrome from this point forward. So armed with my one remaining juice pouch, I called out to them amiably.

"Hey! I have a question for you. And whoever answers correctly wins this drink!" The faces of these five thirsty boys, the oldest of who looked to be about nine years old, brightened considerably. I began, "You know my little girl, the one with the bright pink shirt and the long blonde ponytail?" Their guilty faces looked around in every direction except mine as I continued. "Well, she has a disability. And if you can tell me what it is called, you win." Each one silently pondered the question. "I'll give you a hint. It starts with a "d," and no, she's not deaf," I explained. Still, they were silent and perplexed. "Okay, guys," I coaxed. "What's the opposite of up?"

"Down!" they shouted in unison.

"Yes! Down what?" I coaxed again.

The kid with the dirtiest face said, "Oh! I know, I know! Down syndrome!"

"Yea! You guessed it!" I cheered, tossing him the juice pouch.

"My brother's scared of Down syndrome kids," the dirty-faced kid added.

I laughed, "Oh, no. Down syndrome kids are cool! And they're not stupid, either. Just a little slower. And guess what? Let me see your muscles."

Each boy obediently flexed. "Oh, yeah! You guys could be big, strong bodyguards! If you see anyone being mean to my daughter, or any other little kid with Down syndrome, you can protect them and tell the mean kids to be nice. Will you promise to do that?"

Each boy readily agreed, and we all walked down the hill together.

Lesson #4: People like Blake can bring out the best in others, like diamonds hiding beneath rough edges, if others are open to their influence.

In case you hadn't noticed or haven't reached the little league baseball stage yet, there are always a few parents who don't keep their cool. These parents tend to coach, whether officially or not, quite loudly from the sidelines. One such intimidating father had a son on my son's team. I was glad, if only so my son wouldn't be on the opposing team this overly intense dad rooted for. But during one game, I glimpsed another side of him.

Blake, a boy with Down syndrome who I know well, was on the opposing team. As he got up to bat, we witnessed a reenactment of that email that goes around to all of us parents who have children with Down syndrome that asks, "Where is God's perfection in my son?" As Blake swung at each pitch, this hot-tempered dad evolved into Blake's coach and champion. He cheered with both teams as Blake's bat finally made contact with the ball and he ran the bases, and later ran home. This father had a tender side I had never seen. My throat got tight and tears welled up as I realized yet another lesson.

So go down to those baseball fields, look for new friends or your own diamonds in the rough, and stock up on extra juice pouches. And remember to pack a swimsuit, just in case.

Amy Burton Moore and her husband of 16 years live with their spunky, spirited daughter Kenly Marie, among the wild mammalian creatures of the rural Wild West (where wildlife includes their three energetic and dearly loved sons). Amy has been the editor of Advocate, the Utah Down Syndrome Foundation newsletter, for over a decade and enjoys serving with the amazing volunteer moms on the UDSF State Board (www.udsf.org).

PRAYER FOR GOD

By Melissa Riker

My middle child, Dylan, age 13, has Down syndrome. He has always seemed to have his own special connection with God. Occasionally, he says something that is particularly insightful or comforting.

Five years ago, my mother passed away from brain cancer. One day, I was thinking about my mother and tears came to my eyes. Dylan, who was about 10 years old at the time, said, "What's wrong Mom?" I told him that I was just thinking about "Carmie." Without missing a beat, he said, "Don't be sad, Mom. Carmie is in heaven with God." It's wonderful to have a pure, little soul to remind me of this truth and help me to feel better.

Dylan has always found joy in music. For the past eight years, he has been seeing Miss Kim, a wonderful music therapist. They have a special relationship, and he always looks forward to their weekly session. Miss Kim nurtures Dylan's creativity and helps him express himself through song writing. Dylan writes the lyrics and Miss Kim helps him choose a keyboard accompaniment to fit the mood of the song.

When I picked up Dylan from his session a few months ago, Miss Kim said that I had to hear something. She and Dylan sat down at the piano and began to sing me a song that Dylan had just written. It was so sweet and pure that Miss Kim and I both started crying. Dylan said, "I know, I know, you're crying tears of joy!"

He was right. Parents, family and friends of those with Down syndrome get to cry tears of joy more often than most people.

Prayer for God
Lyrics by Dylan Riker
I wish that I could go to heaven
I want to see you God
You're the best God, in the world
I'll pray to You tonight
When I die, my soul will go to heaven
And see You
I will pray to You every single night
I love You
I miss You and I love You
You are a good God
In the universe, You are the greatest
You're the greatest God ever.

Dylan Riker lives in the beautiful low country of South Carolina with his mother, Melissa, Kevin (dad), Derek (brother), Chandler (sister) and Marley (dog). Dylan enjoys music, drama, movies, video games, playing Miracle League baseball (www.charlestonmiracleague.org) and going to

Disney World. The Rikers are active members of the Down Syndrome Association of the Lowcountry (DSAL at <u>www.dsalowcountry.org</u>.

GOOD NIGHT, FAITH

By Paulette Beurrier

It was just a slumber party. In the life of most little girls, what's another slumber party? In the life of our little girl, it was a milestone—for her and for us.

When Faith was born eight years ago with Down syndrome, weighing only 3 pounds and struggling for life, we wondered what kind of future she would have. Our elder daughter, Joy, was 14 at the time, so we were well-versed in the activities of a typical little girl. But Faith was, by no means, typical.

One thing we were sure about—to the best of our ability and hers—Faith would be treated as "normally" as possible. Preschool, Brownies, kindergarten, Sunday school, elementary school, in every area, whether at home or away, we wanted her to be treated like just any other little girl. Of course, not everyone was as convinced as we were. We received advice to segregate her in special education classes. But we wanted something different for Faith. And so we entered the bureaucratic world of school readiness, mainstreaming, inclusion barriers, accommodations, modifications and revised expectations. We've found that,

frequently, school officials' expectations for her are lower than ours. It is a worthwhile challenge to keep her included with her typical peers in the general education classroom as much as possible. One of our biggest issues is educating the educators.

But how would Faith handle everyday little girl things, like sleepovers? We received our answer last weekend.

Faith was invited to her first sleepover—a birthday party. Of the 10 girls who would attend, six were in her Brownie troop; the others were new to her. Faith's Brownie "sisters" have always been helpful and supportive. Some have been together since attending church preschool. The sleepover mom and her daughter were new to our area, so Faith didn't know them as well as the others.

Saturday afternoon arrived soon enough. We dropped her off with the other eight-year-old girls at 4 p.m. Faith ran into the house and upstairs to greet the other girls. At the top of the stairs, she turned and said, "Bye, Mom." I stayed downstairs for a while and then went up to tell her I was leaving. She was surprised I was still there and dismissed me with another, "Goodbye, Mom!" The sleepover mom took it all in stride, assuring me that Faith would be no problem. I couldn't decide if she was being optimistic or naïve.

I came home and waited by the telephone. Silence. They say "no news is good news," but I wasn't so sure. I stayed up imagining the worst. Was Faith scared? Would she fit in? Would she fall off the top bunk? Was it a mistake to send her? Would she ruin the party?

And still I waited.

By 9 p.m., I couldn't take it any longer. I told myself, one call. Just one call in case Faith needed me, or perhaps the sleepover mom needed some help. So I called, and the sleepover mom said Faith was doing fine and asked if it would be okay for her to have another piece of cake? I hung up the phone with a sigh of relief and a smile.

We picked up Faith the next morning at 10 a.m. We were excited about her accomplishment. She was excited about her adventure and did not want to go home. Sleepover mom filled us in on the details. Faith had slept in a top bunk (another new accomplishment) and went to sleep at midnight, neither first nor last of the girls to fall asleep.

I was so happy to hear her say that Faith would be welcomed back any time. We wondered how Faith would handle little girl things like sleepovers. Now we have our answer: She handles them just like any other little girl.

Paulette Beurrier lives with Jim, her husband of 33 years, and daughter Faith, who loves sleepovers. Her two married children and three grandchildren live nearby. She enjoys volunteering at Faith's school, playing with her grandchildren, reading and playing Mah Jongg. Paulette is secretary for the newly formed local Down Syndrome Organization http://tcdownsyndromeag.org/ and can be reached at lifewithds@yahoo.com.

SAMI GOES TO PRESCHOOL

By Roni Faerman

My daughter, Sami, 4-1/2, has Down syndrome. She attends a private preschool with "typical" kids. When she started, I worried if Sami would have friends.

Last year, she was in a program for two-year-olds with four girls and 10 boys. The boys liked to play rough, but not with Sami. They were always gentle with her. They sensed that she was special. When the children left the classroom, they had to hold someone's hand. The boys wanted to hold Sami's hand and help her walk. They knew she did not talk much and that her physical abilities lagged behind theirs, but it made no difference to them.

Sami's classmates were genuinely excited and happy for her when she answered the teacher correctly. In P.E. class, one little boy would encourage her to jump or run by saying, "You can do it, Sami," as he helped her.

Even though Sami rarely talked at school, the kids considered her their friend. Often, when I walked with Sami after school, the other children would point her out to their moms and say, "My Sami." In fact, many kids referred to her as "My Sami." When she was playing in a

play area with the other kids after school one day, I overheard two kids arguing over Sami. They both insisted, "She's *My* Sami." Sami, however, seemed oblivious to it all.

One little boy in her class loved playing with Sami. The teacher told me that Sami said his name on one of the last days of school. In excitement, he told the teacher, "Sami said my name!" I don't think that Sami talked to him much, but he still loved her and considered her his friend.

Sami's positive experiences with her classmates prove that she does have friends. These small children sensed something special about her. I realized how very special Sami is to everyone, not only me.

Now Sami is in a preschool class with three-year-old children. Her class has four boys and 16 girls. Again, I was worried about Sami having friends. Fortunately, I did not have to worry about it for very long. When I took Sami to school recently, all the kids and their moms were standing outside, waiting to go into the classroom. As Sami walked up, six little girls ran up and said, "Hi, Sami." They were very excited to see her. Sami just smiled and then leaned her back against a wall. The other girls copied her. Then, Sami walked toward the play area and all the girls followed her. I was so proud.

"My Sami" not only has friends, but she is also a leader. The other moms tell me when they ask their kids who they played with at school, they all say Sami. I don't know who benefits more in an inclusive preschool class: Sami or her 19 classmates.

Sami continually amazes me. Her mere presence makes people happy and brings a smile to their face; and

her simplicity seems to bring out the best in everyone, as if they were touched by an angel.

Roni Faerman lives with her husband, David, and their three children, Sami, 5, Ethan, 3, and Bari, 2 months in Boca Raton, FL. They enjoy swimming, traveling, taking cruises, t-ball, soccer, horseback riding and hanging out together. The Faermans are active members of the Gold Coast Down Syndrome Organization, www.goldcoastdownsyndrome.org.

LOSS AND PERSPECTIVE

By Michelle Zoromski

Odds of having identical twins? About 1 in 300.

Odds of having a baby with Down syndrome (DS)? About 1 in 700 (for my age).

Odds of both at once? Who knows? I haven't done the math.

We did not know our girls had Down syndrome until after they were born. We had an ultrasound every month, from 15 weeks on. At one time, they thought the girls were mono-amniotic, but turned out they weren't. We thought that was our big pregnancy scare, and moved on.

Lydia (called Baby B during my pregnancy) had a suspicious marker in an ultrasound at around 20 weeks or so. It was a "soft sign" for DS. On its own, it didn't mean anything. Three soft signs are needed to diagnose, Lydia only had one.

We declined an amniocentesis. After all, I was carrying two VERY active babies, so we weren't worried. (I mean, what are the odds?) And we wouldn't have terminated if one of the babies had DS. I never thought about both of them having it. But I did have a triple screen, which came

back normal. Apparently, those tests are not quite as accurate as we thought for twins.

My pregnancy progressed smoothly. We had ultrasounds every four weeks, and saw doctors for a check up every week as we neared the due date. Everything seemed to be going incredibly well.

At 37 weeks 5 days, we had an ultrasound scheduled. I couldn't wait –at this visit, we expected the doctor to schedule the day to induce labor. He promised to induce me between 38 and 39 weeks. I was relieved, because our older children were both almost two weeks overdue. I looked forward to delivering my babies early.

While performing the ultrasound, the technician looked and looked and just could not detect any movement or heartbeat for Lydia. By this time, we had become pretty experienced at ultrasounds and what to look for. This one was just wrong, in the most heartbreaking way.

Less than two hours later, I was being prepared for a c-section. The anesthesiologist asked if I was in any pain. I was in no physical pain, but I started crying. I tried so hard to keep it together. My husband Brian was brought in and, minutes later, Ruby was born. Her first cry was the best sound I've ever heard in my entire life.

The rest of that day was filled with grief for Lydia and concern for Ruby. She just needed a little help keeping her oxygen level up, so she was in the special care nursery, and I didn't get to see her or hold her until the next morning. She couldn't be brought to me, and I couldn't see her until morning.

Later that night, the nurses took pictures of Ruby and

showed them to me. She was just beautiful. But she was all splayed out--not curled up like a healthy infant. And something was wrong with her arms. They looked out of proportion to the rest of her body. Did I have too much morphine, or was something was wrong with Ruby? Was she a dwarf or did she have dwarfism? (I don't know the correct terminology.) I lay in the hospital, unable to hold Ruby after saying good-bye forever to her identical twin sister. I wished I had Internet access so I could research this. Was the morphine making me paranoid?

The next morning, I was surprised when my doctor said they thought both Ruby and Lydia had Down syndrome, and they would do some testing. Ruby's arms looked strange because she had low muscle tone, and they were very lax. Her low muscle tone made it too hard for her to curl up like a typical infant. As she got stronger, she learned to curl up.

A couple days later, my mom was visiting Ruby and me. She asked my nurse if she could recommend a couple books on DS that she could go pick up from the bookstore. The nurse said, "Well, we have books for you, but we just didn't know if you are ready for them yet."

Surprised, I said, "Bring on the books!" I received a whole packet of information through the local DS group and the local Arc chapter. We were shocked to read about parents who did not want to bring their DS children home, or who were completely devastated by a DS diagnosis. I'm not saying we weren't surprised, but we truly didn't care. I know our journey is unusual, and yet sometimes I forget that. We didn't grieve for Ruby having Down syndrome at

all. We were just overjoyed and thrilled she was alive and well, beautiful and ours.

We got a lot of perspective real fast. In retrospect, I'm glad we didn't know about the DS during the pregnancy. I know I would have worried more, and then blamed Lydia's death on my stress level. It also would have tainted the time I did have with Lydia, because I had a wonderful pregnancy. Lydia was a wonderful baby, so active and beautiful. If only we could have enjoyed her longer.

Michelle and her husband, Brian, live with Ruby and her brother, Braden, in Wisconsin. They all miss Lydia, Ruby's identical twin sister, very much. The Zoromskis are active members of their local Down Syndrome Family Network. Ruby's life is chronicled on their family blog at www.zoromski.blogspot.com.

CHASE'S JOURNEY

BY TOM BAIRD

Okay we get it! Chase has Down syndrome, that's the cool part and what is even better is that he is healthy and happy. There are so many great stories to tell about Chase, it is hard to pick just one to share. You see, one story cannot even begin to describe the incredible and rewarding journey our entire family has experienced with Chase. So we are choosing to share some of the highlights of these incredible first five years.

Year One

In the first few months, my wife, Sharon, read everything she could get her hands on about Down syndrome and then educated me on whatever she read. MacKenzie, his older sister, now had a real-life doll to care for, hold, comfort and have fun with. Chase keeps growing and doing well. Sharon takes him to every therapy available and works with him every day. He makes great progress and I get to hold Chase and play with him when they are done with him, which is never!

The first year passed quickly. We all made it through

with flying colors and had a blast in the process. Along the journey, we met and made lifelong friends who gave us wisdom and courage, but most importantly incredible friendships.

Year Two

Chase is walking and we are on the move! We attended our first national Down Syndrome Convention and, after meeting so many families, we became more confident that we were on the right track in meeting Chase's needs. It was an enriching learning experience for Sharon, MacKenzie and me. Sharon and I also agreed this was one of the best weekends of our lives.

The second year was far from "terrible." Chase was healthy, happy, and wiser and began using more sign language to communicate; and most importantly we all had fun as a family.

Year Three

Chase was up and running. He had a new playmate and baby sister named Reagan. Mackenzie had another real doll to mother, and Chase helped. In this year, Chase earned the nickname "Crusher" and while he was wonderful with his new sister, he could also live up to his nickname.

Chase also learned to swim, although he disliked the work involved. To this day that still holds true. He can hold his breath forever but will not take a stroke. He is the fastest "sinker" we have and we realized he is a great "rock," but not a great swimmer.

As Mackenzie, Chase, and Reagan came together – so did our family circle! We all believe that Chase will continue to grow as any other little boy as long as we allow him to do so. We also realized that **our** goals are not always **his** goals and we will not hold him down by our ceilings. Chase will grow and become whatever he will because of the opportunities that he creates and those that we will hopefully create for him. From here the sky is the limit and he will "crush" any goals we put in front of him.

Year Four

Chase showed some signs of rhythm – the boy can dance! When he hears music, his hips automatically start moving to the beat. For the record, I have to tell you he gets that from me (his dad) and me only! Still sinks like a rock in the pool – but the boy can dance.

Our boy is also going to pre-school! Donned in new clothes, tennis shoes and a backpack, Chase started taking a bus to pre-school. Sharon only cried a little (the whole year). She also continued to open every door possible for Chase so he would have the same opportunities as other children.

Chase is Five (can you believe it!)

Chase got up on skis for the first time and skied twice on our trip to Steamboat. Although he didn't attack the slopes in the same fashion as MacKenzie did, Sharon and I truly understood that children with DS can do activities just like every other typical child their age.

Chase also joined a T-Ball team and hit the ball and ran the bases. He also played on a soccer team. While a little

more challenging and tiring, he played for a strong eight minutes per game. Sometimes it would not be beyond him to lay down in the middle of the field to rest as his teammates picked up the slack. What can I say – he likes to delegate.

One soccer game, in particular, was a very special memory. After the half time break, the players on both teams took their positions and allowed Chase to run and dribble the ball down the field. With both sidelines and coaches cheering, Chase scored a goal. Sometimes, it takes a community to raise a child and we appreciate the help and support we have received.

Year five continues to be very active for Chase. With his classmates, he sang "The Star Spangled Banner" at an Arizona Diamondbacks game. And they say DS slows a child down – yeah, right!

If we could go back to the time before we were married and paint a portrait of the dream we had for our family, I believe it would be the exact image of what it is today with three beautiful children – all healthy, happy, and wise. We would not change anything and would understand that each child is a gift to be cherished from the first day. We are truly humbled to be chosen as Chase's parents and we will never take that for granted.

Tom Baird and his wife Sharon live in the midst of the orange groves of Mesa, Arizona along with their three wonderful children. They are very involved with the local Down syndrome community and serve as Board members of Sharing Down Syndrome of Arizona (www.sharingds.org).

THE TALENT SHOW

Katie has attended CPA, a K-12 private Christian school in Nashville, Tenn., since kindergarten. CPA has a special services department for kids with learning differences, but it provides no special expertise for kids with Down syndrome. Katie's three older siblings attended CPA, and I always felt that it would be a great place for Katie.

When first approached, the elementary principal was hesitant about allowing Katie to attend the school because the staff did not have a lot of knowledge about educating a child with Down syndrome. Finally, the school decided it could probably meet Katie's needs at least through first grade. Through a lot of prayer and dependence on God as the guide and provider of wisdom, Katie stayed at CPA from first grade through eighth grade. She taught many people many things. I was deeply touched by the way God used Katie to teach other children how to accept others' uniqueness and value.

At CPA, kids were taught that God has created everyone in a special way and with a special purpose for their lives. The kids at CPA experienced this in the flesh

through Katie. She loved them, and they loved and accepted her unconditionally. When Katie was in sixth grade, this lesson was evident at the annual middle school talent show. As a side note, middle-school kids can be some of the cruelest, most self-centered beings on earth.

Middle school was tough for my older three children, so it was with great trepidation that we enrolled Katie. Up to this point, however, the kids at CPA had been kind and loving to Katie. They didn't seem to be bothered by her differences.

But knowing how middle school kids can act, I worried their behavior toward her could change radically. When Katie showed me the school's talent show form that needed to be filled out and signed by a parent, I was very apprehensive. I worried that 250 middle-school students would descend into pack mentality and eat my beautiful Katie alive.

Katie had a special talent for dancing to praise and worship music. I was personally touched by the unaffected beauty in the way she worshipped God in dance. I wasn't so sure that her classmates would also appreciate this untrained beauty. Instead, they might laugh at her. I even asked the headmistress if I should conveniently misplace the form to keep Katie from participating. She assured me no one would laugh at Katie.

On the day of the talent show, Katie wore her simple costume and walked barefoot into the school gym with a CD of "Who Am I" by Casting Crowns, a popular Christian band. Nervously, I stood at the back of the auditorium in the hall and took glimpses of her performance while

praying that no one would laugh at her and hurt her feelings. Much to my surprise, Katie received a standing ovation from the entire middle school audience.

When a teacher led my proud daughter to the microphone, Katie told everyone that she danced for Jesus. Needless to say, I shed happy tears and hugged her for making Jesus smile with her dance. Secretly, I was relieved that she made it through this experience and I breathed a sigh of relief that it was over. But, it was not over. The middle school kids voted by secret ballot to determine the winner of the talent show, the ballots were counted, and the winner was to be announced immediately. The headmistress caught me in a back hall and instructed me to go back to the auditorium. I rushed back just in time to hear Katie announced as the winner of the talent school.

The students were so moved by Katie's dance, they almost unanimously voted her as the winner of the competition. Katie took it all in stride and did not seem a bit surprised that she had won. On that memorable day, however, I was reminded that God did not place Katie at CPA randomly. Over the past few years, Katie taught the students at CPA that everyone is different and has a great purpose in their lives. The students at CPA learned an important life lesson that, hopefully, will stay with them throughout their lives.

Debbie and Katie live in Nashville TN with dad Karl. Karl and Debbie also have 3 grown children besides Katie. The Hamilton's are very involved in Young Life Capernaum Project which is a YL program for handicapped kids. They

are also involved in developing Friends Life which is a program designed to create community for the disabled kids that graduate from YL at the age of 21.

GRADUATION DAY

By Kristy Colvin

It's May 27, 2005 and Tim is graduating today. To some, this may be just an ordinary high school graduation ceremony and no big deal. After all, everyone graduates eventually. That is how most people feel because they do not realize what a magnificent feat it truly is. They do not know the struggles that we have faced to get Tim on this stage with his graduating class. They do not know of the stinging and hateful words that were used in explaining to me what others thought his fate would be at various points in his life. They do not know that Tim has beaten every single odd that was against him. Most important, they do not know that Tim has mosaic Down syndrome.

Mosaic Down syndrome is a rare form of Down syndrome in which a percentage of cells have the extra twenty-first chromosome that causes Down syndrome, and the remaining cells are normal. Often, a person with Mosaic Down syndrome does not exhibit the strong physical characteristics or developmental delays associated with Down syndrome.

For Tim, this is the case. He doesn't *look* like he has

Down syndrome and with a lot of perseverance; he was able to overcome most of his developmental delays. He is what the world likes to call "high functioning." He is pretty smart. At most times, smarter than me! Does that make me low functioning?

I have always treated him like a typical child when he was growing up. I never limited him in any way and expected the very best from him. I kept his diagnosis a secret from those who I thought would not give him the opportunity to excel. I didn't tell his teachers. I didn't tell friends. In fact, I didn't even tell him until he was 14 years old when he asked me about it. Sure, my family knew, because telling everyone in the beginning was the best way for me to handle my grief over my son being diagnosed with this rare form of Down syndrome. I had no information that would tell me what to expect.

As time passed, I realized what a true blessing it was to not receive his diagnosis until he was two-and-a-half years old. If I had known this when he was born, I would have treated him differently. I would have stopped him from doing the things that he was capable of doing. And he would not have accomplished all that he has in these past 19 years. So, with that knowledge, I decided that everyone who came in contact with Tim needed to get to know him for the wonderful, creative young man that he is. I wanted them to have the same experience I had during those two-and-a-half years before the diagnosis. I wanted them to see Tim for Tim; not the kid with mosaic Down syndrome. Just Tim.

When I received the diagnosis of mosaic Down

31

syndrome, I was told that Tim would never read nor write. He would be so low functioning that I should consider putting him into an institution. But I did not listen to these negative comments. Instead, I encouraged Tim to excel in all areas. I told the naysayers that Tim would prove their negative diagnosis wrong and that he would not only accomplish the things these doctors believed he was incapable of, he also would excel in each area.

Not only did he read, but in seventh grade he exceeded the state standards and was reading at college level! Not only did he write, but he loves writing so much that he is writing a fantasy novel that, hopefully, will be a great legend from our era! Not only is he not low functioning, but he never attended special education classes and is now graduating with his 2005 class.

Anxiously my husband, Glenn and I hold hands as we sit on the hard stadium seats in the warm pre-dusk hours waiting for our son's name to be called to receive his diploma. As I clutch my tissues waiting for the inevitable tears to fall my sister, Lisa says something to me. "Mmm," I reply. I find myself not able to concentrate on anything other than that stage. I imagine that Glenn is feeling the same way that I am. Although all parents are proud of their children's accomplishments, this is an incredible day for both of us. Because our son has accomplished so much more than just receiving a diploma! He has excelled in every area the naysayers said he couldn't even master!

Most individuals with Mosaic Down syndrome have trouble in math. Although it wasn't Tim's strongest subject, he did stay with his peers even through trigonometry. For a

final thesis in his eleventh grade anatomy class, he gave a PowerPoint presentation on Mosaic Down syndrome. This was a huge turning point in his life. He was able to educate his classmates on mosaic Down syndrome, while revealing that he had this genetic disorder. Not everyone knew in the school, but the few in this class were able to witness this heroic event.

And, for his finale, in twelfth grade, he didn't like one of his scores on his daily grades, so he hacked into the school computer system to change it. Dishonest? Yes, most definitely. But, I had to smile, because even the school's computer technician couldn't figure out how he did it! Back in the corner of my mind, I said, *"Tell me again how low functioning he will be?"*

As the evening's MC approached Tim's name on the list of graduates, I realized that we really haven't done that bad considering all that had been thrown our way. Sure, there were some rough times but, without them, how do you appreciate the times that are not so rough? My parents sat behind Glenn and me during the graduation ceremony. I handed my mother Kleenex to wipe her tears of joy.

I wondered if she was thinking about the day she came with me to receive Tim's diagnosis. Or maybe she was thinking about all of his accomplishments in the past years. She beamed brightly feeling the pride that only a grandmother can know. My father, who rarely showed emotion, smiled ear to ear. We each know that this is not an ordinary graduation ceremony. This is an enormous milestone.

Tim accomplished everything he has set out to do,

proving the negative deliverers of doom wrong when they said that he would not be able to accomplish the things that he has not only accomplished, but also excelled in. He persevered through many difficult times, from the moment he was born two months premature to the relentless bullying he endured in school.

I would like to think that this has something to do with his upbringing. If Glenn and I had put limits on Tim, or treated him as though he had a disability, would he have accomplished all the great things that he has achieved? Would he be the intelligent, caring young man that he is today?

When it was Tim's turn to walk on stage, I readied my Kleenex tissues. Glenn and I squeezed each other's hand. When Tim's name was called, he walked proudly across the stage to receive his diploma. While we cheered louder than ever before, there were others in the stadium that knew of his diagnosis cheering just as loudly. I am sure the folks who did not make it to this event could hear us across town.

As I dabbed my tears, my nine-year-old son, Garrett, asked, "Are you crying, Mom?" I replied, "Yes, but they're happy tears."

After the last name was called, the 2005 graduating class of Franklin High School threw their mortarboards into the air to celebrate their accomplishment. I felt a compelling need to hug Tim and tell him how very proud I am of him. I rushed past all of the other families who were slowly descending the steps of the stadium bleachers and made my way across the football field through the sea of

green graduation gowns. I spotted Tim, ran up to him and hugged him tightly. "I am so proud of you, son." Matter of factly, he replied, "Thanks, mom." (Don't you love those "typical teenage" moments?)

Tim is glad that he has Mosaic Down syndrome. Without it, he says, he would not be the person he is today. What he doesn't realize is that if he didn't have Mosaic Down syndrome, *I* would not be the person *I* am today.

Kristy Colvin is the co-founder and president of International Mosaic Down Syndrome Association. (IMDSA) Kristy lives in Texas with her husband, Glenn, and has five sons. Tim, their middle son, has Mosaic Down syndrome.

LESSONS LEARNED FROM JACK

By Monica Shallow

"It's not something I would have ever chosen, but it's something I would never change"
"God's answer to my prayers for humility and simplicity "

When I think back to that day almost three years ago when it was suggested that Jack might have Down syndrome, I am amazed at my naïvete about that diagnosis. I remember feeling so sad for Jack and for our four other kids. Jack would have to deal with rejection and cruelty from others and struggle to do what others took for granted. I also was sad for Jack's siblings because their little brother had a disability. I feared they would be embarrassed by Jack and would always have to defend him.

Well, I couldn't have been more wrong. Jack has thrived and been warmly received by everyone. Our other kids don't notice his disability. They are proud of Jack the way he is.

Recently, I commented to my husband, Frank, how much Jack has remarkably changed members of our family and many others as well. In ways small and large,

Jack's positive influence has touched our extended family, our friends and their children, the friends of our other children, and even some acquaintances.

Wherever Jack goes, good things happen. He changes lives for the moment, and possibly forever. I feel blessed that Jack is my son. He has revealed so much about life and God's plan for us. Without him, I'm pretty certain we would have missed this lesson.

I envision people with Down syndrome to be the epicenter of our society. Their effects are far reaching and sometimes go unnoticed. To those closest to them, however, their effects are powerful and life-changing. The more intimately involved people are with a person with Down syndrome, the more they will notice the positive effects.

Placed in enough families, children with DS could change the face of our society. Using the epicenter analogy, their effects would overlap until, eventually, every person would intimately experience the powerful and life-changing force of their influence.

In honor of Jack's third birthday, I composed a list appropriately titled "Lessons Learned from Jack." I share these thoughts with you and invite you to share them with others so that we might create our own wave of change. My prayer is that all people will learn that children (and adults) with the diagnosis of Down syndrome should not be discarded. They should be accepted, embraced and, hopefully one day, even desired.

- The top of the stairs is not a good place to leave a basket of clean, neatly folded white laundry.

- Leave people happier than you found them.
- Always greet people warmly and with enthusiasm.
- Not getting what you prayed for is not always a bad thing.
- Don't worry about what tomorrow may bring; enjoy the gifts of today.
- Do chores with a smile on your face.
- Be proud of every accomplishment that you make, no matter how small.
- Dance, even when everybody is watching!
- Strong bonds can form, even among strangers, when a special child is the common thread.
- Never underestimate a person's potential.
- Keep fruit baskets off the kitchen table!
- Bring a smile to the faces of those around you merely by your presence.
- Be more than accepting of people who are different. Be *inviting*.
- What, at first, seems like a stumbling block might turn out to be your greatest stepping stone in life.
- God's answers to our prayers are often so much greater than we could have ever imagined.
- The threat of something more serious may have you praying for that which you once feared.
- God doesn't send special children to special people. Those children inspire those people to aspire to be special people.
- Those predicted to learn the least teach the most.

- People with Down syndrome are much more like us than unlike us; actually, they are not *they*, but part of *us*.
- Simplicity is a beautiful thing.
- Be joyful!
- We are all born alike: loving, trusting and carefree; unfortunately, most of us learn to be different.
- The color of a carrot really isn't important!
- Every day offers the opportunity for great things to happen.
- The positive effects of just one (little) person can be (and have been) countless.

Monica lives with Frank, her husband of 22 years, and their family in Cinnaminson, New Jersey. In addition to Jack, they have four more children: Brittany, 21; Bernadette, 18; Frank, 15; and Augie, 13. Since his birth in 2004, Jack has opened up a whole new world for his family, and they are committed to dispelling fears and increasing acceptance of people with Down syndrome in simple ways.

FRENCH FRIES ANYONE?

By Kay Bradshaw

One Saturday, I brought home some fast food for lunch. I'm not exactly a health food nut, but I do know that french fries are not especially healthy for the body, so it is a rare occasion that we indulge in that scrumptious treat. This particular Saturday, we had french fries.

Parker, our son with Down syndrome, was about six years old at the time. His older brothers and sisters were determined to teach him the "Look out the window!" trick. Over and over, they showed him that if you say in an excited voice, "Look out the window!" the other person will turn his head and you can steal one of his fries. When the kids thought Parker was ready for this trick, their dad walked into the room. Everyone was excited to see Parker in action.

The anticipation was building as Dad sat down at the counter. At the nudging of a sibling, Parker said, "Dad, look out the window!" As was usually the case, everyone was pulling for him. My husband turned his head and played along with Parker by looking out the window for an extra couple of seconds. No one was prepared for what happened

next. Parker quickly placed a couple of his own french fries on his dad's plate. When Dad turned his attention back, he expected to see less french fries on his plate.

To his surprise, everyone's faces wore the emotions that Parker is so good at bringing to our family. Instead of cheering his thievery, we were all humbled at his innocent, generous and loving spirit. Oh, he was proud of himself for pulling off the trick his brothers and sisters had taught him. Little did he know, he taught all of us that the most important lessons of life are learned not by looking out the window, but by looking through the spiritual picture window of this special boy.

Kay Bradshaw lives in Mesa, Ariz., with her husband of 30 years, Mark. They have six biological children, adopted two more children, and then Parker, who was a very pleasant surprise, was born to them Sept. 14, 1997. In addition to their nine children, they are now the proud grandparents of six grandchildren.

SIGNING WITH SANDI

By Colleen Bailey

Suzanne sprung through the door exclaiming, "A young lady with Down syndrome performed sign language to Dove winner Sandi Patty's songs at the Women of Faith conference. It was the most glorious concert I've ever seen. Her presence was simply divine. Your little Ryan can be in front of an audience some day, too."

I was a bit skeptical about such predictions for *my* two-year-old son with Down syndrome. He's learned only a few words in sign language. But Suzanne's bubbling description prompted me to ask more. "Who did sign language? What was it like? How did it make you feel?"

Suzanne's voice cracked, her eyes welled up with tears. This gentle but professional speech pathologist, with her impressive Ph.D., struggled to convey her experience. Surrounded by over 10,000 women in the Century Tel Center in Shreveport, La., in spring 2006, she found only one word that could capture what she witnessed. The young woman with Down syndrome was *angelic*.

Lisa Smith's body swayed to the rhythm of the music

while her hands stretched high in praise and then low in drama. Her heart, body and soul were in such unison that not a word could be heard in the arena. Lisa captured the essence of words in beautiful songs by presenting them in picture with her hands — gentle like a butterfly, commanding like an orchestra leader.

She stole the show.

Lisa was born in 1975. Lisa's mom, Vicki, remembers the blank expressions on the faces of hospital staff when she was born. She remembers being questioned about taking her baby home. She recalls hearing many babies with Down syndrome were institutionalized. But Lisa was born to a mom with grit and a deep desire to raise her baby. Being told not to treat her newborn special seems so ironic now.

Lisa *is* special and her extraordinary gift has reached tens of thousands of people following a "chance" encounter with a professional singer who holds 39 Dove and five Grammy Awards. Singer Sandi Patty speaks of Lisa, "Many of you have had the privilege of seeing my sweet friend, Lisa Smith, do sign language with me at several concerts and Women of Faith events. She is truly an amazing young lady. Lisa is such an encouragement wherever she goes, and I am so thankful that this lovely angel of God has come into my life."

Conference goers were abuzz. Did you hear about the girl who signed with Sandi Patty? Is there any way to get a copy of her performance? Has she been signing all her life? Is she related to Sandi or someone else famous to have such an opportunity?

The answers are as captivating as Lisa herself. Lisa was "signing her heart out using what little sign language she knew in the year 2000," according to her mom, when an elderly couple at church was moved to tears watching her.

Vicki and her husband thought Lisa might really enjoy learning to sign more so they contacted Marla, a sign language teacher at Denton High School in Texas. Marla took meticulous care of presenting material to Lisa in simple ways she'd understand. After a few brief lessons, Lisa astounded her teacher. What takes most students a year to learn was mastered by Lisa in weeks.

Lisa's favorite singer was Sandi Patty, so learning to sign along with Sandi's CDs was a huge motivator. Even with all her progress, Vicki was nervous and protective of her daughter's feelings when Lisa announced she wanted to sign with Sandi some day. Vicki dismissed her daughter's confidence by reminding her that Sandi was a very famous person and advised her to *just pray* about it.

Lisa prayed. Lisa signed. And Lisa attended Sandi's concerts whenever she performed in her area. Lisa was the fan, way up front, swaying and signing every word just as she had been doing in her bedroom for the past couple of years. You couldn't miss Lisa. Her infectious, radiant joy permeates a room because she is extraordinary and very special.

"Some may look at special children as a burden," rebuffs Vicki. Tens of thousands of people have had their burdens lifted by simply watching Lisa's signing with Sandi. Lisa unabashedly embraces and shares her gift. She gives hope and inspiration to parents of all children but

especially parents blessed with special needs children.

A call to Women of Faith Customer Service, early summer 2006, scarcely produced a name when inquiring, "Who was the girl who signed with Sandi Patty?" But after countless inquiries from across the country, the Women of Faith Web site now talks about how proud they are of Lisa.

Mary Graham, president of Texas-based Women of Faith, a division of Thomas Nelson Incorporated, and executive vice president of Live Events for Thomas Nelson, Inc., offered this statement, "Lisa Smith has been an absolute delight and a complete crowd pleaser at Women of Faith events in the past two years. If you've seen her signing with a musician on the platform, you know what I mean."

So how did something so extraordinary come of Lisa's deliberate and prayerful focus? How did this *unremarkable* young lady become involved with the organization that hosts America's largest women's conference?

In December 2004, Christian singer and celebrity Sandi Patty, walked across a concert stage towards Lisa and winked to her as she sat on the second row. Sandi began singing. Her award-winning voice reached the rafters, echoing out into the lobby and filling the hearts of the concert goers. Lisa's signing reached Sandi's eyes and filled her heart. She motioned for Lisa to join her. Never practicing together and barely knowing each other except for a brief introduction by KCBI Radio Station in 2003, they performed in tandem like a beautifully paired duet. Lisa's mom has heard it said, "They have been a perfect match ever since."

On October 3, 2006, Lisa appeared on the *Dr. Phil* show along with prominent speakers from Women of Faith. Some starry-eyed individuals might go on and on about being in the presence of Dr. Phil, his wife, Robin, and other notable personalities. When asked what her favorite part of the experience was, Lisa replied, "Signing with Sandi."

Colleen Bailey and husband, Brent, recently celebrated their 25th anniversary. God blessed them with son, Ryan, in 2003. Colleen finds being Ryan's mom more exciting, challenging and fun than past world travels or job positions. The family is active with the East Texas Down Syndrome Group at www.etdsg.org.

(Lisa Smith can be contacted at www.lisasmith.us.)

OUR STAINED GLASS WINDOW

By Guler Kazancioglu Banford

It was a beautiful August morning of the day we were highly anticipating. We headed to the hospital to have a C-section. It was easy to not wonder when my water was going to break signaling the onset of labor, and not worrying about how long I'd be in labor. Imagine that: You can call and schedule to have a baby. That was a new concept to me, but it wasn't completely without worry. With major surgery, there is always a concern about the outcome. Will the surgery have any long-term health effects on my body? Will I wake up after the surgery? If I don't wake up, what will happen to Adam, my three-year-old son?

I was 29, in good shape and ready for this spirit growing inside me to finally make its entrance into the world. I had no idea the anesthesia would make me groggy for two to three days. Every time I woke up, my husband, Marlo, was at my bedside, loving me and offering kind words of encouragement. He brought Adam to visit me, but every time they went home, I'd miss them terribly. But soon I'd fall asleep.

Our new baby boy, Brett, was very calm and sleepy. He was such a good baby! Three days after his birth, my husband came in and said, "Honey, I have to tell you something."

"Yea," I replied.

"Our baby has Down syndrome."

I'd never heard of Down syndrome, so I asked, "What's that?"

That's when the nurses and doctors came into my room and explained, "Your baby is fine, but he will be a slower learner. Because of his Down syndrome, he has lowered ears, no simian crease in his short stubby hands, his eyes are shaped slightly different, his tongue is larger, and his nose bridge is pressed down."

What were they talking about? I argued, "You have never seen a Turkish baby before. My hands are short and stubby, too. He's a Turkish baby and that's that." Then I went back to sleep.

Brett was a beautiful baby and so tiny. He was 19-1/2 inches long and weighed in at only 5 lbs. 6 oz. He was just like his big brother, Adam, who was 20 inches long and weighed 5 lbs. 6 oz. at birth. Brett, however, was jaundiced and his lungs were not ready for his new world. His heels were pricked so many times they looked painful and broke my heart. This was the first heartbreak of many more to come.

When it was time to leave the hospital, I was told that Brett couldn't go home until his lungs were ready. "You can come whenever you want to visit him. You can pump your milk and bring it to the hospital," the nurses said.

My second heartbreak was going home without my baby. Those were the longest 10 days ever of my life! Yet, I kept busy with Adam and the basement that was being finished for our new arrival. We'd go to be with Brett and couldn't stand to leave him behind after each visit. His jaundice worsened and doctors feared he might need a blood transfusion. Thankfully, God came to his rescue and, at the very last minute, he didn't need a transfusion after all.

It was like a family reunion when we finally brought Brett home, with so many well-wishing visitors. I was still recovering myself and we had to find special doctors, special developmental schools, and fill out so many papers. All I wanted to do was adjust to the new baby in our home and get Adam feeling comfortable with his new brother.

I was born in Turkey and knew nothing about Down syndrome. I had never babysat as a teenager and didn't have a clue about babies, how to care for them, or what to do. My mother had nine children without ever going to a hospital. There was no running water in the house, no electricity, and no doctors. How did she do all that? How did she know what to do? Why don't babies come with a manual?

When I was pregnant with Adam, I read every childbearing and child-rearing book published. I educated myself and was determined to be the best mom ever.

Adam walked when he was 10 months old and could do no wrong. We thought things would be nice and easy with Brett, too, but little did we know about the many new challenges ahead.

When Brett turned 6 months old, we enrolled him in a

developmental school. I sat in the car filling out the papers while crying my eyes out. Why me? Why don't I have a family to help me? If we lived close to my family, we'd have my siblings to help me. Instead, I lived in a country on the other side of the world and there was nothing I could do about it. Tears and all, we'd go to school twice a week and learn how to eat, drink, crawl, and have homework to practice what we learned in class.

Meanwhile, we were busy going to specialists to get lots of tests done to ensure Brett's health stayed on track. Thank goodness for those health professionals and our wonderful pediatrician who also had a child with Down syndrome. I trusted them completely.

Even during his early years in developmental school, people were enamored with Brett's magnetic personality. The media people would photograph and film Brett in class and use the information to educate people about the special school. Many students interviewed us for research on early intervention and its effects on children with special needs and their families. We were more than happy to be a part of this research. After all, everyone needed to know about our darling bundle of joy. To this day, he touches people in ways that words cannot express.

When Brett became involved with Special Olympics, we reached another turning point in our lives which led us on a path to become internationally known in our mission to educate others and become advocates for people with disabilities. Since there was originally no Special Olympics team in our town, we needed to start one. All we needed was one coach and one athlete. Was I crazy? I had gone

back to full-time employment when Brett started kindergarten at age 6. Now he was 11 years old and very active. We needed to harness that energy in the right direction and use it in a positive way.

In September 1993, we started a team called "Dyno-Stars." I recruited his classmates and we were off. Today we have 24-plus Dyno-Star athletes who compete in many different sports. They are state champs in basketball and volleyball, and one of our athletes is the best swimmer in the Utah Special Olympics. After 14 years of managing the team, fund raising and training, it was time to move on to a new chapter in our lives. We handed over the leadership to another parent on the team and focused on our new goals of education and advocacy.

During our fund raising days, I recruited and coordinated many volunteers. Our family, friends and co-workers came to our rescue and volunteered numerous hours and days. Our networking pool grew and we were invited to be representatives of the Utah Special Olympics at different events throughout the community.

Brett signed up to be a Special Olympics global messenger and received a lot of media coverage to spread his message that people with disabilities are capable of achieving many things in their lives. They only need community acceptance, encouragement and support to blossom. Love can help even the most severely disabled people thrive and flourish in special ways.

We recently discovered that Brett's journey on earth is to educate and inspire. He's been on TV numerous times and touches a few more people each time. He's had the

opportunity to meet and speak with a great number of celebrities and has already achieved so much. He was an Olympic torchbearer for the Greece Summer Games. He's also a snowboarder, alpine skier, basketball player, bowler, golfer, has a second-degree black belt in Taekwondo, and is passionate about hip-hop dancing.

When *So You Think You Can Dance* auditions were held in Salt Lake City, Brett was intent on going to the audition even though I had never even heard of the show. So we went without preplanned music or choreography. He immediately caught the producers' attention and impressed them with his dancing skills. He got a call back for a solo dance which had to be choreographed. I didn't know much about hip-hop music myself, so I called a friend at 10:00 p.m. the night before the audition and asked her to recommend a good hip-hop song for Brett. We then changed his music the morning of the audition. Because of this change, Brett had never even heard the song or danced to it; he simply walked on stage cold and winged his choreography. Although he did not make it to the next level of the show, he had the opportunity to showcase his talent and share his message with a national audience when the hosts gave him time to address the cameras after his audition.

Who knows where Brett will lead us with his inspirational journey through life. We do know the next chapter will have us cheering on the Wildcats as he has landed a role in *Disney's High School Musical 3*! Be sure to watch for him.

Guler Kazancioglu Banford was born in Turkey to a family with nine children. When Guler was 14, her English teacher, a Peace Corps volunteer, brought her to the United States. She's been married to her husband, Marlo, for 32 years. They have two sons: Adam, 28, and Brett, 25. The Banfords also have a beautiful granddaughter named JennaVee.

AMAZING CLAIRE

December 22, 2005, at 10:45 a.m. Your first breath took mine away. Weighing only 4 lbs., 3 oz., and measuring 17 inches long, we finally met our daughter, Claire Marie Carlson. I already knew her. She was my other half—the front half and then some—for nine months. She was bruised from not wanting to come out and face the world. She had her daddy's features and was the most beautiful thing I had ever seen.

I thought I knew her. We were told at birth that there was a chance she had Down syndrome. Tests were sent to Mayo Clinic, and six weeks later I felt as though I was holding a stranger. Even at the pediatrician's office, I commented that "God brought you into our lives for a reason." What happened to the perfect little girl we had dreamed about? The one who was going to go to college, move out of the house, get married and rear a family, for Pete's sake? I felt as though I went through a bitter grieving period.

Fast forward three months later. We got involved with Early Intervention immediately at the recommendation of

our wonderful pediatrician. Every day, Claire surprised and amazed us. She became the perfect little girl we dreamed about.

Claire is 22 months old. She has physical therapy twice a week, and speech therapy and occupational therapy once a week. I no longer worry about the physical delays because I know Claire eventually will catch up. I keep her mind stimulated as much as I can. She has a better sense of humor than any little girl I have ever met. She makes me laugh every day.

I want to hold on to her for as long as I can, and no longer wonder about her going to college, moving out of the house, getting married and having a family. Who knows what the future holds for Claire. If she has her way, which she is good at doing, she will conquer the world head on!

Mary husband Dennis, and daughter Claire Carlson live in Seymour, Ind. Claire is now two years old and loves to play ball and dance to music. The Carlsons are active members of the Columbus Area Down Syndrome Support Group (caddsg.org) and the Arc of Jackson County.

MY THREE MIRACLES

By Cathi Hoffman

My journey began in 1992 when I had my first miscarriage at age 27.

One year later, on Oct. 12, 1993, I prematurely delivered Jessica Erin who weighed 3 lbs. 3 oz. I was so scared, but little did I know that I was witnessing my first miracle. After a 24-day stay at LSU Medical Center, Shreveport, La., I brought Jessica home with me to Texas.

I conceived again when Jessica was 3-1/2 years old. Soon after learning of this pregnancy, my husband and I discovered that the fetus was in my fallopian tube. I lost the baby and my chances of conceiving children in the future were reduced by 75 percent.

We resigned ourselves to the fact that Jessica would be our only child, so we focused our energy on making her a very happy little girl. Between 1997 and 2000, I had two more miscarriages. We were absolutely convinced that having another child was not an option. But shortly after Jessica's seventh birthday, I conceived again. My doctor closely monitored the pregnancy during the first trimester to gauge the baby's growth. Our due date was July 23, 2001.

The first four months were happily uneventful, but then I started to dilate at 23 weeks—way too early for a baby to be born. After six days of hard labor, Jacob Edward was born on April 10, 2001, weighing 1 lb. 12oz. Although Jacob had only a 22 percent chance of survival with major complications, he surprised the doctors, sailed through the NICU, and was released after only two months at Christus Schumpert Medical Center in Shreveport, La. This was my second miracle.

My husband and I agreed this was the stopping point. We were blessed with a daughter and son, who survived against the odds. To prevent any future complicated pregnancies, I had a tubal ligation in June 2001.

Three months later I had some concerns and went to see the doctor. I left his office speechless after three pregnancy tests and an ultrasound confirmed I was three months pregnant. (This means I conceived right before the surgery.) I was not convinced that my health would allow me to carry another child. What were the odds of having another survivor?

I was determined to have a successful pregnancy, and I did everything I possibly could do to make this pregnancy longer and healthier. On Feb. 16, 2002, I gave birth to Julia Elise, my third miracle. She was beautiful at birth with the face of an angel.

When Julie was one month old, I took her to a new pediatrician. After a full examination, Dr. Chris asked my age. When I replied that I was 36, he said Julia might have Down syndrome. Her blood was sent to a lab for chromosome testing and three weeks later, Dr. Chris phoned with Julia's test results.

He began by saying, "Mrs. Hoffman, we have Julia's test results and, unfortunately, she has Translocation Trisomy21."

Unfortunately? Using that word was not the right way to tell me. To this day, I see nothing unfortunate about it. Quite the contrary, I felt that God gave me a compliment by choosing me as the mother for this child. Under the circumstances of her conception, my husband and I believe Julia is here by God's will and she is our earthbound angel. I have never been disappointed in anything that I experienced with my children, and I would trade lives with no one. My kids have all surpassed expectations, so we know that Julia will continue to learn and love life as her siblings do.

Today, Jessica Erin is 14 and in eighth grade. She plays on her school's basketball team. She is taller than me and has no medical problems. Jess was given to me when I really felt the need for love.

Jacob, 6, is in first grade and he is being tested for the gifted/talented program. He is the child who taught me faith.

Julia is doing well in an age-appropriate life skills class and has a wonderful teacher. Since this teacher has taken over the classroom, Julia has made amazing progress. She is the child who has given our family joy.

No matter what Julia has learned, she has been the real teacher. We have learned that the word "can't" is not an option and that even on a bad day, a simple smile can make everything better. When Julia suddenly bursts into laughter, that's her way of saying that we are going to be just fine.

Through Julia, I have met many people who have made me realize how rewarding a child like Julia can be. I have decided to make a career in special education. Whether I'm a teacher, a teacher's aide or a volunteer, I feel compelled to be with these children. I thank God every day for the miracles that he has given me, and I thank Him for the gift of Julia.

Cathi Hoffman lives in Hallsville, Texas, with her husband, Ed, and their three children, Jessica, Jacob and Julia. Recently, Julia was diagnosed with autism disorder. The Hoffmans continue to welcome and jump each hurdle that comes their way.

HEAVEN ON EARTH

By Kevin Huff

It is 5 a.m. and I am fast asleep when my wife, Shawnie, wakes me with her touch. She tells me that her water has broken and that it is time to go to the hospital. It is three weeks earlier than planned and I have not packed yet. I begin throwing things in the bag as I remember them from that packing list we received from the birthing class we attended three months earlier.

In an ultrasound a few days earlier, we had found out that our son might not be swallowing and that we should do more tests before he was born. Now, it is too late. We are just hours from giving birth to our first child.

That point forward started our life's turn for the better.

Braxton was born later that morning and the few minutes following the birth was the most amazing experience ever. The nurses handed him to his mom and he looked straight into our eyes. The feeling of having our first child and the intensity of his gaze left us both in tears. It was a wonderful experience for a brand new family.

Soon after, we discovered that Braxton had Down syndrome and that his esophagus did not reach his

stomach. Both of these were big surprises to us, but we were much more focused on Braxton's health concerns than him having Down syndrome.

The next two months brought with it a lot of ups and downs for us. Braxton had surgery the day after his birth to insert a feeding button. A few weeks later, he had a surgery to fix some intestinal webbing. Six weeks after birth, he went in for a major surgery to connect his esophagus to his stomach. At four hours into the surgery, we were told that it would not be successful. Four hours later, the doctors gave us the good news that they tried again and successfully completed the surgery. A week or so later, Braxton was drinking from a bottle. A miracle had been performed and we were grateful.

After 10 weeks in the hospital, we were bringing our little one home. We had his room ready since Shawnie was three months' pregnant. Shawnie said that it was a bit too early, but I couldn't wait. It was nice to have a child's room in our home. It felt good.

Now that we had him home, we settled into our routine of minor surgeries every three weeks, administering medications, and feeding him by bottle with supplemental feedings through a feeding tube. By the way, burping a baby with a feeding tube is a bit challenging. Eager to meet other parents of children with Down syndrome, we became involved in a wonderful local support organization. This is where we developed friendships that will last forever.

Even with Braxton's medical needs, he was a joy to have in our home. He was mostly happy and had the most

contagious laugh I ever heard. He would babble with the softest and warmest little voice. He loved it when we read to him. As every page turned, he would have the biggest expression of surprise.

We celebrated Braxton's first birthday with family. Braxton really enjoyed his day. We played with new toys. He had cake and ice cream, and received lots of tickles.

A month later, he got sick and over the next couple of weeks, his health continued to deteriorate. Even with many visits to the doctor and ER, things grew worse. On the morning of January 19, I found him in his crib no longer breathing and color gone from his face. He had passed away earlier that morning. This day was the most painful memory I have and, to this day, I cannot recall it without mourning. We loved our little miracle and will always keep his memory close to our hearts.

After Braxton passed on, we continued to stay involved in the local support group. Our friends were there and we loved being around these great little kids. As can be imagined, we missed Braxton a ton. But we also missed the idea of raising a child with Down syndrome. We were looking forward to all the exceptional adventures that we would share with our son as he progressed throughout his life. We even discussed that at some point in our lives we would adopt a child with Down syndrome to help alleviate some of our disappointment.

After trying for years to have another child, Shawnie informed me in the middle of the night that we were pregnant. The pregnancy went without a hitch until we had an ultrasound and found out that our baby girl had a

heart defect. Later that month, we went to the cardiologist and found out that the heart defect that our baby had was reasonably serious and could likely be repaired by surgery. The other bit of news was that 50 percent of children with this type of defect also have Down syndrome. It was hard for us to believe that we would have another child with Down syndrome. So we waited for the final verdict to be announced at her birth.

A few seconds after birth, I could see that our little girl had Down syndrome before anyone else noticed. Even though the news was a surprise, we rejoiced that she was alive and absolutely beautiful. We even got to spend some intimate time with her before she was carted off to the NICU where they could perform some tests. So with that, our lives continued to be enhanced.

We brought Tia home with us soon after her birth. Although she would need surgery at four months old, she would be fine until then. To keep her healthy, we kept her at home except for brief trips to the doctors. We even had our date night at a place where we could order our food and eat in the car. Even with these restrictions, we were so happy to have such a small one in our home.

Over the next few months, life at our home was lived like there was no tomorrow. We spent as much quality time as possible with Tia. However, our anxiety continued to escalate as her surgery date approached. Even though there is a high percentage of success with her particular type of heart surgery, there is always a chance that we could lose her.

At four months of age, we admitted Tia into the

hospital for open-heart surgery. One of the more stressful moments of our lives was in between the time they told us that she was on the bypass machine and when they told us that her heart was beating again. The surgery was a success and Tia is not expected to need any further surgeries. The recovery time in the hospital was only five days. We brought her home to continue healing. Soon she was fully recovered. Tia now has a ton of energy, loves music and dancing, and is a real social butterfly.

Tia loves to say her prayers and acknowledge a long list of those she is thankful for, including all of the immediate and extended family members, Barney and friends, and Daddy Warbucks from Annie. We also sing "Happy Birthday" to Daddy most nights before we pray.

Recently, Tia joined a baseball team and has adapted quickly to the crowd cheering as she turns the corner at third and approaches home plate. When she reaches home plate, she lays down. This is her rendition of sliding at home, which she learned from one her teammates. As she heads back to the dugout, she bows to the crowd and yells, "THE CROWD GOES WILD."

Before getting pregnant again, we decided to meet with a geneticist to discuss our chances of having another child with Down syndrome. We were not worried about our children having Down syndrome, but we did worry about medical issues so often related to it. We could not bear to lose another child. Because both of our children had non-disjunction trisomy 21, the geneticist told us that having a third child with Down syndrome would be extremely rare and something he had never heard of.

Immediately thereafter, Shawnie was pregnant again. We had a few ultrasounds that confirmed that our baby was healthy. In early spring, Tyler was born in good health and big surprise...he has Down syndrome. We consider ourselves very blessed that he is healthy.

We have become a very unique family and are blessed because of it. We also learned that any future children will have a 50 percent chance of having DS. So we made the decision not to have any more biological children. This was a difficult decision as we know we will miss out on raising a typical child and being grandparents. We are considering adoption as another option for growing our family.

Getting back to Tyler...he has a sweet demeanor and gentle heart. He has always been fascinated with his big sister. Whatever she does, Tyler will follow. This has been great for his development. He is also our big eater and loves chicken nuggets, French fries, and his favorite – pizza!

Tyler loves to show off his talents. With his sister, he plays the game we call "Show Me What You Can Do." He demonstrates his amazing dancing and singing skills, as well as gymnastics, and he loves to be cheered on. Tyler also loves to listen to bluegrass music. He dances and plays his harmonica along with his favorite songs. He also likes to wear hats and play with his toy fishing rod. You would think that we were raising Huckleberry Finn.

He also has a great sense of humor. When he is asked a question, he responds with the wrong answer on purpose and follows it with the biggest smirk. His favorite animal is the elephant and he talks about it all the time, especially on the phone with his grandmas.

Tia is now six years old and Tyler is four. As I write this, I am in Belgrade, Serbia, in a children's home visiting a 16-month-old boy named Andrija, who we will name Max. After 10 months of paperwork and waiting, we have come here to adopt him. And yes, he has Down syndrome. The initial plan was to adopt a "typical" child, but we feel that God had another plan for our family.

We adore children and adults with Down syndrome, and we have been blessed with the knowledge and resources to rear children with Down syndrome. That being said,

we decided to add Max to our family. His nickname is Smesko, meaning "Smiley Boy" in Serbian. He is always smiling and giggling, and is very curious about his environment. He will be a perfect fit for our family.

Shawnie is already looking for other adoption opportunities. We have been blessed with many things in our lives to offer our children. And our children reciprocate that and much more. Because of them, our lives are full and meaningful. Our home is heaven on earth.

Kevin and Shawnie Huff live in Gilbert Arizona. They are parents of four wonderful children with DS. They serve the DS community in multiple capacities including being board members of Sharing DS Arizona www.sharingds.org.

Shawnie is a registered nurse and offers guidance to those parents with children that have come with medical trials. Both Kevin and Shawnie strongly believe that people with DS provide a great value to the community and strive to educate others about this untapped resource.

FRIENDSHIP BALL

"Pass it to me!" I cannot tell you how many times those words exploded out of my daughter's mouth during the recreational basketball season in our hometown. And I never thought that anyone on her team would ever pass it to her during a game, especially not during the final game of the season.

Ever since Ana was an infant, she has been throwing anything that she could get her hands on, including bottles, toys, books and food. And amazingly enough, she was fairly accurate. Her accuracy improved each year, in spite of her loose joints and ligaments due to Down syndrome.

By the age of three, she could dribble a basketball better than her older brother. Maybe it was because Ana is very stubborn and was bound and determined to do whatever her big brother did. Or maybe it was because of the encouragement of a friend of the family who loves all sports, especially basketball. Whatever the reason, Ana would go out on the driveway and shoot basket after basket. She was never discouraged when she missed the basket more often than she made it.

When she was old enough to join the recreational basketball team in third grade, we signed her up. She was very excited about playing, although she wasn't thrilled about running back and forth across the court. In fact, there were numerous times during the first season when she preferred to sit on the bench and cheer on her team mates. The only difficulty was that she rooted for both teams because she had classmates on both teams. Ana didn't see it as a problem to encourage members of both teams. She just understood that they were her friends and friends should cheer for each other.

When fourth grade rolled around, Ana signed up again to play on the basketball team. Now she was familiar with the rules of the game and knew that when she was open, she should shout, "Pass it to me." Her team mates passed her the ball during practices, but no one ever passed it to her during the games. All season long, she ran back and forth on the court but never had the opportunity to dribble, pass or even attempt to make a basket. But she never gave up playing or shouting "Pass it to me" until the last game of the season when there were only a few minutes left in the game.

The clock was ticking down during the final game when one of her team mates passed the ball to her. Ana cautiously dribbled down the court and with great concentration, raised her arms and let the ball fly toward the net. During this entire period, members of both her team and the opposing team completely stood still, allowing her to take her time. They did not even attempt to take the ball away from her. Ana's basketball headed towards the backboard

and swished down through the net. Ana turned, raced towards the other side of the court, arms raised in victory, with a glorious smile on her face yelling, "I did it!" But she wasn't the only person in that gym smiling – so were all the members of both basketball teams. Meanwhile, the audience clapped and hollered along the sidelines.

A short time later, Ana's team once again had possession of the ball and when she yelled, "Pass it to me!" her team mates complied. And like a replay on tape, Ana dribbled towards the basketball net while members of both teams stood still. She took another shot towards the basketball goal, but this time it was short. But it didn't matter to Ana. She was thrilled just to get the opportunity to be a part of the team and attempt to make a basket.

After the game, I asked a game official if she had arranged it so that Ana could attempt to shoot a basket. Imagine my surprise when she said she had nothing to do with it. She added that both teams wanted Ana to have the opportunity to try to make a basket, but it took them a while to coordinate it.

Ana says "hi" to everyone she meets in her school and treats all her classmates as friends, and her friendship was paid back in full at the last basketball game of the season. Ana's friends made sure that she had the opportunity to truly be a member of the team and shoot a basket—not once, but twice. I'm not sure who was more elated, Ana or her classmates.

Ana knows how to be a fantastic friend and she has made an endless number of lifelong friends. This time, however, friendship was passed to Ana.

Denise Sawyer lives in Mulvane, Kan., with her husband, Scott, of 17 years and their two children: Arron, 13, and Anastasia, 11. She is a teacher of special education at the secondary level, is active in her church and is the secretary of the Down Syndrome Society of Wichita, http://www.dsswichita.org/ She spends the majority of her spare time being a cook, taxi driver, cheerleader, housekeeper, advocate and loving mother.

THE JOHNNY STORY

By Barbara A. Glanz

I am an author and a professional speaker. I travel all over the world speaking about motivating and retaining employees, building customer and employee loyalty, and regenerating spirit in the workplace. Several years ago, I was asked to speak to 3,000 employees of a large supermarket chain, an experience which led to one of the most heartwarming blessings of my entire speaking career.

My presentations focus on the idea of adding a personal signature to your work. With all the downsizing, re-engineering, overwhelming technological changes, and stress many people experience, it is essential to find a way we can really feel good about ourselves and our jobs. One of the most powerful ways to do this is by differentiating yourself from other people in your field. The following examples illustrate this point.

- When everything was under control in the cockpit, a pilot went to the computer and randomly selected several people on board the flight to receive a handwritten note thanking them for their business.

- I know a graphic artist who always encloses a piece of sugarless gum in everything he sends his customers, no one ever throws away anything from him.
- A Northwest Airlines baggage attendant decided that his personal signature would be to collect all the luggage tags that fall off customers' suitcases. In the past, the tags would have been simply tossed in the garbage. In his free time, he mails them to the customers along with a note thanking them for flying Northwest.
- A senior manager decided that his personal signature would be to staple a piece of Kleenex® to the corner of memos bearing bad news to employees.

My personal signatures are evident throughout my presentation. No matter where I speak in the world, I always line the walls of the conference room or ballroom with many brightly colored, laminated flip charts with handwritten quotations that relate to my presentation topic. Some are intellectual, some are funny, some are spiritual, and some are just common wisdom. It sets a wonderfully relaxed atmosphere for learning.

After sharing examples about how people add their unique spirit to their jobs, I challenge my listeners to create their own personal signature. I am also a writer, so I always give my home telephone number to everyone in the audience and attendees to call me and let me know what they have decided to do so that I can share it with others through my speaking and writing.

Three weeks after my presentation to the supermarket employees, my phone rang late one afternoon. The caller introduced himself as Johnny, a bagger at one of the stores who has Down syndrome. He said, "Barbara, I liked what you said!" He added that after my speech, he went home and asked his Dad to teach him to use the computer.

He said they set it up a document in three columns, and each night he finds a "thought for the day." He said, "If I can't find one I like, I think one up!" Then Johnny and his father type the message six times on a page, and print out at least 50 pages each night. He cuts them out, and signs his name on the back of each one. At the supermarket the next day, Johnny places his "thought for the day" in every grocery bag.

One month later, the store manager phoned me. "Barbara, you won't believe what happened today!" he exclaimed. "When I went out on the floor this morning, the line at Johnny's checkout was three times longer than any other line." He continued, "I went ballistic and yelled, 'Get more lanes open! Get more people out here!'"

The customers said, "We want to be in Johnny's lane so we can get the thought for the day."

The store manager also regaled me with the story of a woman who told him that she used to only shop once a week, but now she comes in every time she goes by the supermarket because she wants the thought for the day!

Three months later, the store manager called me again, "You and Johnny have transformed our store. When there is a broken flower or an unused corsage in the floral

department, employees find an elderly woman or a little girl to pin it on. One of our meat packers loves Snoopy, so he bought 50,000 Snoopy stickers, and each time he packages a piece of meat, he puts a Snoopy sticker on it. We are having so much fun, and our customers are having so much fun!" That's what I call spirit in the workplace!

Johnny regenerated the spirit in a workplace by adding his personal signature to his job. Imagine the new spirit of self-esteem, commitment and fun which could permeate your workplace if added a special, unique touch to your job.

This story is excerpted from CARE Packages for the Workplace — Dozens of Little Things You Can Do to Regenerate Spirit at Work, Barbara A. Glanz, 1996, CARE Packages for the Home—Dozens of Ways to Regenerate Spirit Where You Live, Barbara A. Glanz 1998, and The Simple Truths of Service Inspired by Johnny the Bagger, Ken Blanchard and Barbara Glanz, 2005.

Barbara Glanz, CSP, works with organizations that want to improve morale, retention, and service and with people who want to rediscover the joy in their work and in their lives. She is the author of The Simple Truths of Service As Inspired By Johnny the Bagger; The Simple Truths of Appreciation — How Each of Us Can Choose to Make a Difference; What Can I Do? Ideas to Help Those Who Have Experienced Loss: Balancing Acts. For more information, visit www.BarbaraGlanz.com.

MY ANGEL

By Rachel Blank

My daughter, Kerra, 17, was diagnosed with Mosaic Down syndrome when she was five years old, but I knew she was special from the first day she was born. I was 19 and scared to death about being a young mother, but Kerra made it easy. She was a very outgoing, happy baby who rarely cried. She just seemed so content all the time, at peace and happy. Her biological father had a drug problem, and left when she was only two.

Kerra and I were on our own for a very long time. She was nine when I married again. Looking back at my life, I don't know what I would have done without her. We took care of each other. Kerra did well in school and she loved to read. She would sit in her room for hours engrossed in a book. Her favorite kinds of books are mystery, comics, poetry and scary books. Kerra now volunteers at the public library in our town and they love her there. She also belongs to our church's youth group. Once a month, the group visits the residents of a local nursing home. The older people enjoy seeing Kerra because she plays games with them and makes everyone laugh.

Kerra has a beautiful voice and takes singing lessons. The priest at our church asked her to sing "Ava Maria" in front of the church during communion at mass. As a self-conscious teen, she says she is not ready for that, but in her room she sings like a bird.

When Kerra was 10, her stepfather formally adopted her. Then, she became a big sister when three more children were born in the next three years. She immediately loved and accepted her siblings, although she was a bit jealous sharing me with three other kids and a husband.

Recently, our family suffered a loss. Kerra's grandpa (my father) died of lung cancer at the age of 55, and Aunt Lauren (my sister) died of an accidental overdose at the age of 26. Everyone was devastated, including Kerra, although she was (and still is) the positive force who carried the family through the grief. When her Grandma Chris would cry, Kerra told her not to worry because PaPa Ernie is always in our hearts and we will see him again. There are no words to describe the priceless gift Kerra is to all who know her.

Sometimes, I think I learn more from her than she learns from me. For example, when a new family recently moved into our neighborhood, Kerra befriended their 12-year-old girl. After awhile, this girl started teasing Kerra, tricking her, taking advantage of her and using her. Kerra refused to believe what was going on and she kept making excuses for the girl. Eventually, this girl stopped hanging around Kerra because she met other girls her age at school. I was relieved, but Kerra still refused to believe anything negative about the girl.

A few months later, Kerra was riding the bus home from school. A song came on, and she started dancing in her seat with her arms above her head. Apparently, she forgot to shave under her arms and that girl noticed. She said loudly, "Look at the orangutan dancing. Gross!" Kerra was humiliated and came home in tears. I was furious, but Kerra did not want me to say anything to the girl. This girl had a birthday slumber party the following week, but did not invite Kerra.

This didn't seem to bother Kerra. She wrapped up one of her own pretty necklaces and took it over to the girl, wishing her "Happy Birthday." When Kerra returned, I asked her why she gave the girl a gift after she made fun of her in front of everyone. She replied, "Oh, mom, she didn't mean it and, besides, I forgive her. Isn't that what God wants us to do?"

I was in awe and to this day Kerra never ceases to amaze me. I learn how to be a good person from her example. She is a true gift from God.

Rachel Blank and her husband, Tom, live in Northern Kentucky with their children: Kerra, Tommy, Amelia and Claire. Kerra loves to read comic books and Goosebumps, play video games, write scary stories, swim, and spend time with her family.

ANDY AND HIS SHOW CAREER

By Dorane Strouse

Andy, like all children with Down syndrome, is special. When he was born, another mother of a child with Down syndrome visited us at the hospital and offered words of encouragement. She recommended that we stimulate Andy in every way so that he would develop well beyond our expectations. Since that day, Andy and I have had the theme: "I can do it." I pledged not to set up challenges that were impossible to achieve, and Andy learned to try his best. He seldom failed, except for learning to tie his shoelaces. Soon he was talking, reading, writing and spelling. Later, he went on the computer and memorized an amazing amount of information, including the top songs over the last 50 years and when they came out.

All of these wonderful accomplishments aside, this story is about something Andy has enjoyed and excelled in that few, if any, other people with special needs have ever attempted. Andy became a national champion in the world of animal showing.

When Andy was only two years old, I retired from my executive position so I could devote more time to helping

him in any way possible. Shortly thereafter, I acquired llamas as a hobby and turned it into a business. Llamas, known for being gentile and safe, are ideal for handicapped people. With our business, we showed llamas. Andy grew up helping to feed them and also worked with our llama supply business. He loved to pick out items and assemble them for shipping.

One Thanksgiving Day, our llamas were in the Thanksgiving parade in Detroit. We took one young llama named High Spirit to the parade, and he was a natural. High Spirit loved the crowd and was unfazed by all the people, noises, streets and machines.

By then, Andy was 14 and just beginning to have an interest in showing llamas.

Llama showing, like horse, dog and other animal showing, has a traditional halter class but also includes performance classes, such as obstacle, public relations and pack, where the handler and llama must negotiate a course. For example, on an obstacle course, they might have to cross a bridge, walk through water, weave through a maze, do some jumps, etc. On a public relations course, they may encounter people who pet the llama, a dog to greet, or a trailer to enter and exit. A pack class is similar to an obstacle course but the llama must carry a pack and may encounter obstacles normally seen on a pack trip, such as going over a deadfall of tree limbs.

We felt Andy would enjoy performance classes, and he eagerly began training with High Spirit. They clicked instantly. High Spirit seemed to have a natural understanding of working with Andy, whose first experience showing him was

at an exposition at Michigan State. It was more of a demonstration show than actual competition and he and High Spirit did well.

Andy's first real competition came at a llama show in Mount Pleasant, Mich. At that time, llama shows did not have special needs classes. All people competed in the same classes, did the same obstacles and were judged on the same criteria. And like all other show competitions, people came to do their best and win. Andy entered two classes that day: obstacle and public relations.

When he started the obstacle course, all activity in the facility stopped and it was silent. Most of the people there knew Andy and loved him, but now they were seeing a first—a handicapped person competing. They knew it was a special moment. Andy did well—not perfect—but everyone could now see he was capable of competing. When he finished, there was a loud applause.

About an hour later, Andy entered the show ring for his second class, public relations, and again everyone stopped and watched. Slowly and carefully, Andy and High Spirit negotiated the course. About halfway through, you could hear whispers and low-level "wows." I leaned over to my wife, Terri, with eyes full of tears and said, "He could win this." When he completed the course, the crowd cheered.

Andy finished second out of 12 entrants. He ran with excitement to receive his ribbon. It became an Andy trademark. He liked to win, but he was always very happy just to compete and get a ribbon.

Andy's career showing llamas had begun. Andy and

High Spirit competed for years winning many firsts, seconds and thirds. To other contestants, he became a feared competitor. They loved him, but they were happy when he wasn't in their class. Llama people marveled at the rapport between Andy and High Spirit, and said they had never seen anything like it before. If Andy took time going over a jump due to physical challenges, High Spirit would just wait patiently for Andy to clear and then finish the obstacle.

Andy and High Spirit also would compete in a "Leaping Llama Contest" where the bar kept being raised and the llama must jump over without knocking it off. Andy and High Spirit usually won. They even set a record that still holds when High Spirit jumped over a 54" high bar from a standstill. They also won a "llama limbo" where the handler and llama must go under a bar and they won that too.

Andy's llama showing has been a wonderful world. He has competed in hundreds of shows in at least 11 states, including the National Show. At the National Show, the obstacles are more difficult and the competition is much tougher.

Andy had 32 in his class from all over the United States. When he started on the course, everyone stopped to watch. Many people from the West had heard about Andy, but had not seen him compete and knew they were seeing a unique and special competitor. Andy did not disappoint as he and High Spirit performed to almost perfection.

When they came to obstacle number 8, there was a large waterfall and the goal was to go under the fall to

avoid the water. Andy misunderstood and went right through the rapidly falling water. He was drenched and High Spirit followed his lead without hesitation right through the water. They both were totally soaked.

The crowd burst into laughter. Andy look puzzled, and then he and High Spirit both shook off the water and proceeded to the next obstacle. Even with this mistake, the duo finished in ninth place.

Later at the show, the American Llama Show Association presented Andy with a special award as "Sportsman of the Year." He received a resounding round of applause and there wasn't a dry eye in the audience.

Time has gone by, but Andy continues to show. High Spirit is still living, but retired from showing because he injured a leg after slipping on ice and can no longer jump. Andy now works with a llama named Star, and he continues to touch the lives of those around him.

Dorane and Andy live with Terri, Andy's stepmother, in Caledonia, Mich. Andy lives half-time with his mother, Diane, in Grand Rapids, Mich. Andy is very active and loves Special Olympics sports, including baseball, swimming, soccer, basketball and bowling. This year, he also did the polar plunge to raise money for Special Olympics.

THE PIANO

By Jennifer Graf Groneberg

Avery loves the piano. He sits tucked on my lap, where he becomes very quiet and takes quick breaths in anticipation. I open the music book to the only two songs I know: "As Time Goes By" and "Someone to Watch Over Me." When I was pregnant with Avery and his fraternal twin brother, Bennett, I'd play the songs over and over, end to end, so that it seemed as if I had a full repertoire.

The piano is a simple upright made of old, dark wood. Some of the keys stick and it's missing one of the knobs that pulls the cover shut. It's a gift from my friend Phyllis, who plays beautifully. She knew of my secret wish to learn and when she saw the piano at a garage sale, nearly abandoned, its keys stripped of their ivories, she thought of me. She brought it home and cleaned the wood, repaired the broken strings and glued on new ivory. She worked until the piano could be played for the first time in years. It was a surprise birthday gift. She gave me a song and a piano to play it upon. "It has a lovely tone," she said. "You never would have guessed looking at it."

As I play now with Avery balanced on my lap, I think

about his left ear. When he was first born, we were told many things. We were told he needed to be checked for a heart defect (which he did not have) and for gastrointestinal problems (again, nothing). We were told he would grow slowly, and would most likely have respiratory issues (also, no). And we were told he was deaf in his left ear.

At the time, the news struck me as inconsequential, compared to what seemed to be the larger fact of his life—Down syndrome. Phyllis said, "He's got two ears, right? And the other one works just fine." But I had darker thoughts. I remember thinking, at least it's not Bennett. I didn't know if I could handle two babies with special needs. (I wasn't sure if I could handle even one baby with special needs.) Let Avery take it all, I thought. Let him have all the trouble. I think part of me was angry at him for being born different than I had expected.

I wasn't sure I could be Avery's mother, and I wasn't sure how to talk about that fear. So I read, and tried to learn as much as I could about Down syndrome. What I found didn't put my mind at ease—in fact, it made me more certain than ever that I wasn't qualified to raise such a child.

In particular, there was a brochure from the National Down Syndrome Society titled "Myths and Truths." I took it as a sort of pretest, which I failed. I believed all the myths. Down syndrome is not a rare genetic disorder, but a common one. People with Down syndrome are not always happy; they have a full range of emotions, like everyone else. People with Down syndrome are not severely retarded, but fall into the mild to moderate range. Down syndrome is not fatal, and 80 percent of

adults with Down syndrome live to age 55 or beyond.

I kept reading. I learned that during normal cell development, a single cell begins to grow by dividing and duplicating itself over and over. Sometimes, for reasons that are not yet known, the original cell does not divide equally. It continues to grow and duplicate itself, and its error. When the extra genetic material is located at the twenty-first chromosome, it is called Trisomy-21, which is also known as Down syndrome.

Although babies with Down syndrome have extra genetic material at the number 21 chromosome, all of their other chromosomes are normal. In fact, the material in the number 21 chromosome is normal, too—there is just more of it. And I learned that there is great diversity regarding intelligence, learning styles, physical ability, creativity and personality, because of the influence of the other 46 chromosomes in each baby's genetic blueprint, a chain of DNA that when linked end to end would reach the moon.

We scheduled an appointment to have Avery's hearing retested when he was three months old. The test was inconclusive. We returned when he was nine months old. This time, he passed. The audiologist said, "This is the most beautiful tympanogram I've ever seen. I wish all children had such clear ear canals."

Sometimes when I play the piano with Avery sitting on my lap, I look down at his left ear and wonder about the failed hearing test. I have all sorts of theories: There was fluid in it from the C-section. Or, the machine malfunctioned. It was simply a bad test. Or, his ear canals were too small. He just needed time to grow.

I needed time to grow, too. I needed time to forget the son I imagined I was having, and allow this new son to show me who he is. At three years old, Avery is a boy who loves music. He loves to read. He loves our elderly cat, Cosmo, and watches out for him with tender concern. He will eat oatmeal until his little round belly looks likely to pop; or yogurt; apples or peas. He will pick the meat out of a sandwich and eat it, but discard the bread. He dislikes potatoes. He has a weak spot for spoonfuls of raspberry jam straight from the jar.

I have learned, too, that Down syndrome is a part of Avery, but not the most interesting part. There is more to him than meets the eye; a whole person you might never have guessed at just by looking at him. If I can learn that, maybe others can, too. These are my hopes, and my hopes are the notes of our song. Avery is bouncing his legs and clapping his hands to the sound from the piano, the only child of mine who can keep a beat. Soon Avery is plinking the keys, too, and I am forced to abandon my usual repertoire and go off the page. We play together while making music from the heart.

Jennifer Graf Groneberg lives and writes at the end of a twisty gravel road with her husband of 15 years and their three young children. She is the author of Roadmap to Holland: How I Found My Way Through My Son's First Two Years with Down Syndrome, (NAL/Penguin, 2008). You can read more about her and her family at www.jennifergrafgroneberg.com.

MAKING CONNECTIONS

By Judie Hockel

Early on in raising Christi, who turns 29 this Christmas, I understood that our most important goal was to connect her to the rest of the world.

In the 1980s, teachers didn't think children who had Down syndrome were capable of learning to read and write. The word "plateau" was commonly accepted as the end result of their learning capacity. But Christi was blessed with an exceptional special educator who didn't believe people who have Down syndrome "plateaued" any more than the rest of us do. She delighted in seeing how far she would go, and single handedly created inclusive education for her special students before the term was known, thereby connecting Christi to the general education curriculum, as well as numerous typical students who came to see her as an individual, not a syndrome. One Thanksgiving weekend, five years after graduating from high school, Christi took a call from a classmate inviting her to an impromptu class reunion at a local nightclub. Of course, she went and loved every minute of the party.

Searching for and weaving found threads of connectedness has resulted in a young woman who loves to learn, has impeccable cursive handwriting, graduated from high school with a diploma, and spent two semesters in junior college as a teaching assistant for a drama class. Instead of stagnating atop some vague plateau, Christi continues to adapt her ability to read and write, connecting her in our modern technology to others via email and text messaging. She still researches topics of interest and writes papers about them, downloads song lyrics on her computer, and is a regular at imdb.com searching out cast lists. On a recent solo flight to Dallas from San Francisco, Christi had to change planes in Denver, texting to me a reassuring, "I made it to Gate 17 all by myself."

It was frustrating throughout those school years when most education professionals continued to have low expectations. After I spent five years preparing her to earn her learner's permit, we asked the school district to provide specialized student driver training for Christi. Viewing this as a silly request for a person with Down syndrome, the program specialist referred to a life skills transportation assessment done earlier and noted, "I see you mentioned here that Christi cannot as yet safely walk across the four-lane highway intersection near her home," implying that they viewed the provision of transportation training as a continuum along a spectrum of progress.

I pointed out, "It's true. It would be dangerous for her to walk across that busy intersection, but yesterday she safely drove our car through it." We prevailed, receiving

the services of a professional driving instructor, whose dedication and patience made it possible for Christi to pass her driving test on the first try. I still wouldn't feel she's safe driving on our insane freeways, but she *can* drive a car to pick up her best friend at her nearby home, and bring her back to her apartment for a weekend together watching "I Love Lucy" and staying up way too late.

Another professional asked me what the point was in enrolling her in regular high school classes, especially the Spanish I class that she repeated over and over. "Why does she need to learn Spanish?" We know the point: It's another strand connecting her to the world around us.

We were shopping one afternoon in a hardware store near a predominantly Mexican section of town, when Christi spotted a Hispanic woman pushing a stroller carrying an infant who clearly had Down syndrome. The look on that mother's face validated the four years in Spanish I, as Christi confidently approached them, saying with an excited smile in her voice, "Hola! Me llama Christina. Como se llama su nina?"

Not perfect Spanish, but the point was made, as it has been repeatedly in her three decades of life. Our kids don't plateau, and they are gifted in reaching out to meaningfully connect with others everywhere, be it in an airport, a nightclub, or a hardware store.

Judie and her husband live in Walnut Creek, Calif. Christi, the youngest of their six children, plans to marry and move to Dallas, which would leave Judie no choice but to get her own life. Until then, she occasionally writes on

http://upswithdowns.blogspot.com/. Meet Christi at http://www.ndsccenter.org/selfadvo/speakers_bureau.ph p?speaker=Christi

HOW MUCH I LOVE YOU

By Tom Prior

Our daughter, Brenna, is 16 years old. She is very excited about life, music, dance and people, like many children with Down syndrome whom we have met along the way. Brenna can swing mentally and emotionally from eight to 16 years of age, and completely blow us away by saying or doing something beyond that age range.

Some things that Brenna has said and done make me wonder if she has a special entryway into the next world. Both her grandmothers, for example, have been dead for six to10 years now. She knew them fleetingly, but out of the blue she will ask, "Do you miss your mom? I do!" In and of itself, that's probably not too intuitive, yet I'll get goose bumps when she asks. It's as if her grandmothers are reminding us not to forget them!

The series of events that occurred about three years ago has always stuck with me as an absolute, pure "heavenly" connection and still does. I own my own business, a small cabinet shop/renovation company, which is a one-man shop. Summers have always been a challenge for us and mostly for Sue, my wife. Long before

school lets out for summer, she's busy trying to line up camps, sessions, sitters and events that will occupy, teach and keep Brenna active during the summer months while we can both continue to work. Invariably, there would be long periods of a week or two when we couldn't find or afford anything for Brenna to do.

It was no different this particular summer. Sue couldn't take off work to be there for Brenna as she sometimes could. As for me, well, when I don't work, I don't get paid. I was renovating a house, but the owners allowed me to bring Brenna with me while I worked.

Brenna is easily entertained. She likes to sing and dance to music, make up songs on her guitar, and draw her own creative masterpieces, with plenty of snacks and orange juice within reach.

This summer, I had a lot on my plate. I was working two jobs at the same time. I had some subcontractors dealing with one job so I could consistently be on the other. In addition, I was anxious about a pet project I wanted to put on the market myself.

Now, I want to backtrack a bit to explain something that is relevant to the story. When Brenna went to bed, she insisted on reading her favorite book, "Guess How Much I Love You," a story about a daddy rabbit, Big Brown Hare, who tries to get his son, Little Nut Brown Hare, to go to sleep. When Big Brown Hare asks, "Guess how much I love you?" Little Nut Brown Hare would respond, "How much?" "To that tree and back," said Big Nut Brown Hare. Not to be undone or to show how much he loved his dad Little Nut Brown Hare, would ask the same question of his

father and the two would go on and on.

One morning during rush hour, we were driving down a crowded highway to the job. I was very quiet because I was preoccupied with how badly some things were going on both jobs, when Brenna asked out of the blue, "Dad, do you see those clouds over there?" as she pointed above some high- rise buildings. "That's how much I love you—from that cloud to here!" I looked at her smiling face, not knowing whether to laugh or cry—so I did both!

Somehow, she knew what I needed that day. And not just that day either. When school resumed at the end of summer, I would drive Brenna to school and then go to work. Once again, I was steeped into my business/financial thoughts. Suddenly, I felt a little hand on my shoulder. Turning toward Brenna, her head was tilted and a smile on her face. She didn't say a word as she continued to lightly pat my shoulder, and brightened my day.

Happenstance? Maybe. Tuned in? Definitely! We still believe she, as well as all children in their innocence, are a special link to the spiritual world.

Tom, Sue and Brenna Prior live in Austin, Texas. Brenna attends "Not Your Ordinary School" (NYOS) Charter High School where she is fully included and involved in classes and social events with her peers. Brenna loves to sing, dance and play music. Tom runs his own cabinet shop and renovation business. Sue works part time for a non-profit agency called Texas Parent to Parent. They are all active members of the Down Syndrome Association of Central Texas.

PURE JOY

By Suzie Smith

This story begins before my daughter was born. I was the mother of four at that time: Brittany, my stepdaughter, and Henry, Kenny and Tim, my biological sons. But, there was someone missing. Thoughts would flash through my mind about having a little girl, but there were two obstacles in my way: I could no longer bear children, and my husband, Jeff, who is 10 years older than me, was not remotely interested in having more children.

In fall 1998, my thoughts of a daughter grew stronger and I finally talked to Jeff about it. He thought I was crazy, but he listened. At the same, farther north in our state, there was a pregnant 17-year-old girl, Alison. Soon, our stories joined together as one.

By January 1999, I had talked Jeff into attending an adoption meeting. He agreed to start the required mountains of paperwork, but he was taking his sweet time. We were told because we had "normal" children, we would have to adopt a child with special needs. I agreed to the terms – what's "normal" anyway? I even discussed various disorders with our pediatrician. Jeff and I agreed

that we would be willing to accept a child with Down syndrome, among a list of others. Then spring arrived, and everything stopped.

I can't remember what prompted me to tell Jeff not to worry about finishing his paperwork. A week later, I received a phone call from the adoption agency because I had omitted the ZIP codes for our references. And just as quickly as things had stopped, they started back up. Strangely enough, I later learned that during this time period, Alison was told that her daughter would have Down syndrome. I am sure that termination was mentioned and I am very grateful that it was not the final option.

Although events transpired quickly after that phone call, it seemed like forever. Jeff finally finished his paperwork, and I knew instinctively that we would be getting a daughter with Down syndrome. Our case worker came to our house for a home inspection and was compelled to tell us, even though Jeff's security check had not been completed, that a baby girl with Down syndrome was being born in early August. I told him I already knew about her—she was mine. Even before we were notified officially, I remember standing on the street corner talking late into the night with a friend and crying. I felt so bad for the other families that would not be getting this precious baby girl.

When June arrived, our case worker called and asked if we could meet in his office. He had some news for us, and he told me to bring the boys. Jeff met us there. I was given a letter to read. The first paragraph read:

"I am so grateful that I got your family to choose from. You guys sound almost too perfect! I feel so very blessed to have you guys as the parents of my child. When I got that letter from you it brought tears to my eyes and softness to my heart. I know my baby will be with the perfect family and that you will love her and guide her on the right path."

In response, I wrote Alison a letter dated July 12, 1999:

"Names are very important to me. I know the meaning of all my children's names. My name means Lily of the Valley, so the baby's name is Lily. I think it's only fitting that her middle name is Alison. Our little angel is named after her two mothers, who love her the most in this world."

Lily Alison was born on July 27, 1999. She spent the first two-and-a-half months of life in the hospital. She was born without an esophagus and her intestines were malrotated, but she is perfect. When asked to describe her, my response is always "pure joy." I have never in my life prayed so hard to my Heavenly Father or have had such a wonderful spiritual experience with my heaven-sent daughter.

Suzie Smith lives in Holladay, Utah, with her husband, Jeff, and their five children: Brittany, Henry, Kenneth, Tim and Lily. Suzie is the state president of the Utah Down

Syndrome Foundation, <u>www.udsf.org.</u> She also enjoys volunteering at the VA nursing home, reading, watching anything about World War II, and spending time with her family. You can read more about Lily on her blog at <u>http://lilyslifeisgreat.blogspot.com/</u>

JOY = ACCEPTANCE + COURAGE
+ FRIENDSHIP + AWARENESS

By Tom Lambke

I was 26 when our first child was born. My wife, Karen, and I had been married four-and-a-half years and we were looking forward to starting our family. As I watched the doctor deliver our son, I noticed our baby's almond-shaped eyes and immediately realized that he may have Down syndrome. I remember wondering, "Who will I play baseball with?"

Looking back 26 years ago, I know that was a very selfish thought. I could not have predicted that Bryan would grow up to be a young man who now enjoys playing every sport, except baseball!

Yes, Bryan was born with Down syndrome. Ironically, Karen's older sister, Camille, also had a baby boy born with Down syndrome. Unfortunately, Patrick was born with several health issues and passed away just after his first birthday. That did not give us or any other family member a chance to learn much about Down syndrome, so Karen and I really had no clue what to do. The library only had a couple of books, both written by doctors in a

way that was not useful to us, and there was no Internet at that time. So Karen and I decided to do what we thought was best for Bryan: We raised him as a "normal" baby.

When Bryan was one year old, he showed us the courage that we would witness so many more times as he grew up. He went through open heart surgery to patch a hole in his heart. Just before they wheeled him to the operating room, he looked up at me and said his first words, "Da-da." I knew then he was a fighter and that everything would be fine.

Bryan survived the surgery and has grown into an interesting, lively and funny young man. He has always attempted whatever we have asked him to try—that has always impressed me. When Bryan was eight years old, we got him involved in Special Olympics. He ran the 50-meter dash, the 200-meter relay run, and did the softball throw.

In the past 18 years, Bryan has competed in basketball, bowling, swimming, dragon boat racing, kayaking and Challenger baseball. He has excelled at each (except baseball), and has won many medals and ribbons. His most treasured medal is the gold medal he won in Unified bowling at the 2003 Special Olympics Summer World Games in Ireland.

To capture this incredible experience, I wrote a book titled *Spirit, Courage and Resolve … a Special Olympics Athlete's Road to Gold* (www.spiritcourageresolve.com). The book takes the reader from Bryan's birth to Ireland.

We have met many people because of Bryan, some

famous and all incredible. We have had the honor of meeting Eunice Kennedy Shriver, her husband, Sargent, and daughter, Maria. We even rode next to Maria and Arnold's kids (Gov. Arnold Schwarzenegger of California) during a Best Buddies Bike Challenge.

We also can count as one of our friends, the incredible Chris Burke from the television show, *Life Goes On*. We have been given a tour of Fenway Park by Shonda Schilling, wife of Curt Schilling of the Red Sox.

Bryan has changed my life dramatically. I have gone from high school and college to the United States Marine Corps and a career with the postal service and a courier company. I am now a special education paraprofessional in the Medically Fragile Unit for a local high school. I have been working with people with disabilities for the past five years, but I have had 26 years of training. All of this experience has given both me and my wife tremendous insight into many processes within the education system, most important of which is developing a proper Individual Education Plan (IEP) for kids with special needs so they can be protected and we can get everyone in the school system focused on the same goals to be successful.

Bryan and I wrote a second book about Down syndrome. We use this book when we talk to schools and educate the public about disabilities and Down syndrome awareness. Although Bryan does not talk as much as I do, he does a great job answering students' questions.

Our two books have been sold in all 50 states and 12 countries. We are extremely proud that *I JUST AM ... A Story of Down Syndrome Awareness and Tolerance*

(www.ijustam.org) has been translated into Romanian and French and can be found on Eunice Kennedy Shriver's desk.

I grew up a punk kid who called people retards if they were "different." After spending some years on a high school campus, I hear the word used daily and never in a good way. My brother, Ken, gave me a special present for my 50th birthday: a German Shepard with three legs! Because of Bryan and our dog, Ozzie, I am now a person who advocates for people and animals with disabilities

I am blessed with my wife, Karen, of 31 years and our daughter, Shauna, who is 23. But having Bryan in my life changes the way I look at each day and makes me strive to be a better person. He has brought me JOY by his ACCEPTANCE of the life he was given; by his COURAGE in the face of adversity; by his FRIENDSHIP to all those around him; and by his AWARENESS of others. Bryan has helped me make peace with myself and allows me to help others. He has helped me to face life's challenges positively. Through his attitude toward others I have discovered a new side of myself. Because of Bryan I now see others who are different, differently, and I am proud of the JOY that has brought me.

Tom lives with Karen, his wife of thirty-one years, and Bryan and his sister, Shauna, who is twenty-three. Bryan has worked at the Chandler AMF Bowling Center for four years and is still quite active in Special Olympics. Tom is a para-professional in Special Education at McClintock High School in Tempe, Arizona, and is also a full time

sports official. The entire family regularly participates in Special Olympics Unified sports and Best Buddies Bike Challenges and are active members of DSNetwork of Arizona (www.DSNetworkAZ.org).

THE M & M BOYS: A DOUBLE MIRACLE

By Ruth Siemens

Two identical twin boys, Matthew and Michael, were born eight weeks prematurely on February 18, 2003. Fortunately, they did not have any heart problems. That gave the boys a head start on the long road that lay ahead, for them and their family. Their parents, Steve and Paula, and their grandparents (Paul and I), prayed for them before they were born and continue to turn to God. Both boys have Down syndrome, but it is only a small part of who they are.

They have inspired me so many times as they struggled with their special needs. The medical staff at the Medical University of South Carolina/Charleston in the Neonatal Unit and the Special Care Nursery has been a huge blessing to us. Their knowledge, encouragement and support to our family have been enormous.

M & M have taught me unconditional love and patience. They are happy little boys and enjoy life. They like to dress up and dance to the music in front of the mirror, teaching us it is okay to laugh at one's self. Even when an activity is difficult to learn, the boys never give up.

They were first taught the alternative method of sign language when learning to talk. It is fast and saves on words. Plus you get to talk with your hands just like mom! We don't always know what they are thinking because the twins don't talk very well, but they are always finding creative ways to communicate; for example, taking someone's hand and guiding them to what they want. They have shown me the power of a hug, a smile or a laugh.

They teach us to not be afraid. One of the challenges that they have overcome is fear of the water and now they love to swim. They also enjoy books, music and children's movies. Climbing, sliding down the slide and swinging come in a close second.

Matthew and Michael take one day at a time. Each day is a celebration as they accomplish something new. They seem to know that God will provide for them through mom and dad, grandparents, aunts, uncles, cousins, nieces and nephews, teachers, medical staff and friends.

The twins teach us to depend on God, to be thankful for each day and to look to scripture for comfort and answers:

- Jeremiah 33:11 NIV—*Give thanks to the Lord Almighty for the Lord is good; his love endures forever.*
- Proverbs 3:5,6 NIV—*Trust in the Lord with all your heart and lean not on your own understanding: in all your ways acknowledge Him and He will make your paths straight.*

These boys always seem to find a reason for excitement and smiles. Playing T-ball has been a thrill. One day, Michael hit the ball and the crowd cheered, so he stopped and clapped with a big grin, and then continued his run to the base.

The twins went to bowling alley the same day. The bumper pads were in place so the boys could bowl. Matthew took his turn rolling the ball and then lay on the floor with his chin in his hands and patiently waited for the slowly rolling ball to knock a few pins down.

The boys are now five years old, and continue to be a source of amazement to us as they handle the special needs that many other children haven't experienced. We all feel blessed by God that He has entrusted Matthew and Michael into our care.

Ruth Siemens grew up on an Iowa farm and says, "Farming has been my life, helping my husband, Paul, until he retired. Spending retirement in the Heartland of America brings contentment to us. It's a great place to enjoy one of my favorite pastimes of reading. Now that I have the time to write, too, it has been satisfying to put my thoughts on paper and inspire others that may experience similar circumstances in life."

WALK ON

By Cynthia Lehew-Nehrbass

Sitting high atop her white thoroughbred, my daughter catches sight of my wave, and smiles. With bright eyes, rosy cheeks, and her brown hair tucked neatly in a braid behind her pink hearing aids, Sarah hovers beautifully on the cusp of her teenage years. And although she is still lean and petite, today she looks exceptionally tall and self-assured on her trusty steed.

Her straight back shifts as she reaches for the reins in front of her. Hagi snorts and Sarah giggles. With the heels of her riding boots wedged securely in their stirrups, she lifts up to stand, before plopping back down onto the worn leather saddle. Signaling to her side-walker volunteers that she is ready, Sarah looks down from under the bill of her riding helmet, smiles and whispers, "Walk on."

Guided by a leader and rope, Hagi plods forward in a saunter and begins his slow trek around the dusty arena. Together they join the rest of Sarah's adaptive riding class in a warm-up routine of circular laps around the indoor shed. Practicing balance, Sarah stretches her arms up, places her hands on her head, then leans over to touch

These boys always seem to find a reason for excitement and smiles. Playing T-ball has been a thrill. One day, Michael hit the ball and the crowd cheered, so he stopped and clapped with a big grin, and then continued his run to the base.

The twins went to bowling alley the same day. The bumper pads were in place so the boys could bowl. Matthew took his turn rolling the ball and then lay on the floor with his chin in his hands and patiently waited for the slowly rolling ball to knock a few pins down.

The boys are now five years old, and continue to be a source of amazement to us as they handle the special needs that many other children haven't experienced. We all feel blessed by God that He has entrusted Matthew and Michael into our care.

Ruth Siemens grew up on an Iowa farm and says, "Farming has been my life, helping my husband, Paul, until he retired. Spending retirement in the Heartland of America brings contentment to us. It's a great place to enjoy one of my favorite pastimes of reading. Now that I have the time to write, too, it has been satisfying to put my thoughts on paper and inspire others that may experience similar circumstances in life."

WALK ON

By Cynthia Lehew-Nehrbass

Sitting high atop her white thoroughbred, my daughter catches sight of my wave, and smiles. With bright eyes, rosy cheeks, and her brown hair tucked neatly in a braid behind her pink hearing aids, Sarah hovers beautifully on the cusp of her teenage years. And although she is still lean and petite, today she looks exceptionally tall and self-assured on her trusty steed.

Her straight back shifts as she reaches for the reins in front of her. Hagi snorts and Sarah giggles. With the heels of her riding boots wedged securely in their stirrups, she lifts up to stand, before plopping back down onto the worn leather saddle. Signaling to her side-walker volunteers that she is ready, Sarah looks down from under the bill of her riding helmet, smiles and whispers, "Walk on."

Guided by a leader and rope, Hagi plods forward in a saunter and begins his slow trek around the dusty arena. Together they join the rest of Sarah's adaptive riding class in a warm-up routine of circular laps around the indoor shed. Practicing balance, Sarah stretches her arms up, places her hands on her head, then leans over to touch

her toes. She pats Hagi's mane and then his robust rear, never once looking to me for reassurance. My stomach flutters with joy. I am no longer needed as her encourager. Today, I am simply her celebrator.

I watch as Sarah weaves in and out of orange cones in figure eights and variations. She stands in her stirrups, bouncing a trot. I am awestruck. She isn't showing off or vying for my attention—she is just asserting her independence and enjoying herself.

I look down at her once constant riding companion in my hands, a faded lime green ballerina frog. His legs dangle under my fingers, a reminder of how Sarah loves to shake them into a dance. His eyes and fabric, worn and dirty, show the signs of nearly seven years of faithful love and service to Sarah in all her daily activities.

I think back to that first day nearly three years ago when Sarah gripped Froggie, dug her heels into the dirt, desperately trying to get enough courage to climb onto her very first horse.

That early autumn day, we arrived at her therapeutic riding school with a mix of excitement and apprehension. After waiting over two years to reach the top of the school's well-sought out waiting list, we traveled nearly 40 miles into rural Minnesota to experience the program's benefits. But the school's riding shed, nearly as large as half a football field, smelled of hay, manure and horse sweat, and was definitely unfamiliar territory for my daughter. Sarah held Froggie tightly in her fingers, as she watched the four-legged creatures kick the ground and whinny.

"Horse," she said, over and over, her index and middle fingers placed together near the top of her head, bending quickly into the sign of a horse.

"Yes," I agreed, then raised my eyebrows and crossed both sets of fingers moving them in front of me to sign the question, "Ready?"

She nodded and looked back toward the other riders who were quickly mounting their horses with the assistance of instructors. Placing her open hand on her chest, she said with excitement, "My turn."

The gate swung open and her teacher said, "Sarah's turn. You get to ride Gunner." Sarah peeked inside the arena toward the horse that was being pointed out, and then reached for my hand in apprehension.

Gunner was a huge ivory Norwegian Fjord with a black-tipped Mohawk for a mane. He was not the regal black stallion of Sarah's movies and books. Although he had recognizable hoofs, a swishing tail and familiar sideways glance, he was nearly the size of a small car.

Gripping both Froggie and my hand, Sarah reluctantly followed her teacher into the arena. I guided her onto the mounting platform and into a large plastic chair before once again retreating to join the sideline throng of first-day parents, siblings and extended family. As I walked away, she shifted her eyes suspiciously between the approaching beast and me.

The volunteers led Gunner to Sarah's side, encouraging her to pet her horse. Next to the large platform, he looked monstrous. But Gunner appeared to be well-trained and mild-mannered, leaning gently in to

make it easier for her to reach him. From Sarah's vantage point, however, he must have seemed just big. She remained seated and looked at me. From behind her glasses, I could see her eyes widen.

I signed a reassurance of "it's okay" and an encouragement of "go, sit on the horse."

She shook her head an emphatic "no," and placed Froggie by her face in a poor attempt to block the large Gunner from her view.

I smiled and gestured to my nose a sign of "fun," trying to remind her of all the joy she had received from watching others ride in equestrian shows on TV, and visiting the stables at the state fair. Although she looked the part of a professional horse rider, fashionably decked head to toe in riding gear, tapered pants, snapped blouse and denim vest with tiny embroidered horses, she wasn't buying it. Looking like a rider and actually getting on the horse were too completely different things.

After a few minutes, her instructor coerced her into standing, but she remained gripped to the chair's arms with its legs jutting out behind her. I grinned at the thought of Sarah perched high on the saddle: Froggie, chair and all.

Her instructor finally managed to pry loose her fingers and the chair fell behind her.

"C'mon, Sarah!" everyone chimed as her body stiffened. She dropped her gaze to her feet and began shuffling in place in what at first looked like an attempt to move forward. But then her fear guided her feet into a moonwalk-scoot backwards. The teacher placed her hand

on Sarah's back and gently reversed my daughter's momentum to a forward progression. Instantly. Sarah was face to side with Gunner's broad back.

After many minutes of indecision and various creative modes of coercion, the instructors asked if Froggie wanted a turn. Reluctantly, Sarah gave up her alter-ego for sacrifice and he was placed onto the saddle. I should have seen it coming. Froggie, in all his bug-eyed greenness, was the first to get his ears examined, the first to take medicine, the first to slide or swing, and the first to raise his hand in school. And much to my annoyance, he was also the first to check out the temperature of every swimming pool and ocean wave, and the first (and fortunately, the only one) to try to fly out the window of our moving car. Hence, Froggie has had more than nine lives, and was the perfect choice to break in Gunner.

Sarah patiently watched as her beloved, well-loved partner in crime rode atop the enormous Gunner. Her eyes followed her amphibian friend, supported by side-walkers, as he made not one, but two full rounds of the arena's circumference.

There were plenty of knowing smiles and supportive giggles by other parents who had apparently experienced something similar with their own riders; but Sarah's mouth remained pursed in a straight line. This was serious business. Eyes glued to her friend, she waited.

By the time fearless Froggie returned, Sarah was ready to be placed on the saddle behind him. Success. Together, backs stiff and held, and with legs in near splits over Gunner's wide back, Sarah and Froggie joined her class for

the remaining ten minutes of the hour, walking round and round.

For the whole first and part of the second year of Sarah's riding classes, Froggie was a regular cowboy. But over time, the need for his assistance lessened. Before today's class, Sarah even handed Froggie to me on her own accord and entered the gate willingly. She proceeded to hold the stirrup by herself, placing her foot in, and hoisted her own leg over the saddle without fear.

The feeling of wonderment that sweeps over me in tingling warmth as I watch Sarah reach down to give Hagi another hug is based on respect. The fact that my daughter manages to conquer her fears to follow her dreams is why I count her as one of my mentors. She teaches me daily how to tackle new skills, with a combination of patience and passion, and how to work through uncertainty and hesitation with perseverance and creativity to reach a desired goal.

A few months ago, I faced my own Gunner. I was severely apprehensive about reading one of my essays in front of fellow writers and family. It was the very first time since high school that I had ever been in that uniquely vulnerable, critical situation with my writing. I was petrified. Then, I remembered my daughter, the subject of my essay, and all the struggles she encounters daily to experience life's fullness. Through her example and her riding journey, I was able to stand behind the dreaded microphone and hear my own voice unveil words about my beautiful daughter. Sarah's bravery was my own little Froggie, my guide. She had been my inspiration more than once that night.

I don't know if my daughter will ever realize just how much she inspires me. Yes, there are many ways she understands the impact she has in my life. She can tell, with the millions of smiles and kisses we exchange, the joy I feel simply being in her presence. She knows she can make me laugh in all the quirky things she does every day to entertain me: dancing silly in the rain, starting pillow fights, and walking around in my shoes. She even knows that she comforts me with a warm hand to my cheek or crawling up next to me on the couch when I've had a hard day and says, "It's okay mama." In her kindness, I experience in Sarah the purest form of unconditional love I've ever known.

But I don't know if she will ever realize that I am inspired every time she asserts herself, in all her precious uniqueness. That, when she risks to fail, simply because she enjoys the freedom to try; that I am learning from her. And I don't know if I will ever find a way to convey to her, that after nearly 13 years of having her in my life, I am a better person, more confident in her shadow.

"Fast," I hear Sarah saying as she rounds the corner of the arena, standing high in her stirrups. She starts shaking the reins, in an attempt to nudge stoic Hagi into a final trot.

I know Sarah well enough by now, having watched her rewind her favorite scenes in the horse movie, *Flicka*, multiple times. She wants to run.

Sarah has memorized the scene where Flicka runs through the mountain meadows and forest, with a young girl on her back. The girl is smiling and laughing; her hair swept up in the motion and breeze. I know that Sarah

wishes and dreams of being that girl riding Flicka, able to run free, not holding back, caught up in the graceful galloping rhythm. I also know that it could be years, if ever, before she might achieve that dream, especially since Hagi hardly wants to trot.

And, as I watch her turn to me—not out of concern or for reassurance, but with pride—and see her sending me an extended, long wave with her wrist and a self-sufficient smile, I know that if anyone can reach that dream, it will be my daughter.

Walk on, Sarah, I smile, holding Froggie to my chest.

And, I can almost hear her sweet, nearly teenage, independent voice in my head saying, "Fast, Hagi, fast." Someday.

Cynthia is the mother of two Sarah and Jacob. She has a bachelor's degree in dance and owns a dance studio in Minnesota with her husband, Jeff, who is a Lutheran Pastor. After more than 20 years of a career in performance, choreography and teaching, she has rediscovered her passion for writing. She most recently published an essay for the National Down Syndrome Congress newsletter, and is currently working on a collection of stories for memoir, with her children being her main inspiration and muses.

Grace was born just before Thanksgiving of 1994. She was premature and at a low birth weight of under three pounds. Her first year of life was one long hospital stay, having survived a near fatal heart surgery, pneumonia and RSV. Now at age 13, Sarah has a moderate hearing loss

and an amazing zest for life. She continually gives her family a perspective on what is most important life: faith, love, laughter and play.

You may contact her at cindy@onyourtoes.org.

THEY SAID IT COULDN'T BE DONE!
THE STORY OF DEBBIE BURTON

By Felton Burton

Optimistic, caring, deeply religious, knowledgeable of politics, happy, intelligent—all of these describe a wonderful young woman. This was Debbie Burton, a.k.a. "Miss Inspiration" to all who have had the privilege of knowing her.

Debbie Burton, born September 29, 1952, was a very ill "blue baby," but her family did not know until weeks later that she had a problem. Nor did they know that she was expected to live but a short time. As mothers do, Doris Burton soon recognized symptoms that she didn't want to face. This baby had unusual facial characteristics; she did not react to sights and sounds, as did other infants; she displayed little or no physical activity. Then a visit to the pediatrician confirmed Doris's worst fears: the doctor had known from the beginning that Debbie had Down syndrome. He did not tell the parents this when Debbie was born, trying to save them grief and thinking that the baby would not live very long.

When Doris gave her husband, Felton Burton, this

diagnosis, he was—needless to say—devastated. However, devastated as both were, they never considered placing their child in an institution, as was usually the custom and as they were advised to do. Instead, they accepted her as their own, gave her tender loving care, and treated her as they did the other children, who knew Debbie only as their beloved sister. As she began to grow and achieved some mobility, she joined in activities with her sister and brothers, amazing all who knew her. One of five children, Debbie wanted to do everything they did, an early sign of her determination.

She played football with her siblings and always accompanied her family on vacation. She went to the beach with her family and learned to like the water. She went with them to Disney World and participated in whatever her brothers and sister did.

Never timid or intimidated, Debbie was aggressive and assertive and didn't realize that she was any different from other children. She also was disciplined like the other children; for example, she had occasional tantrums when she wanted to have her way (as children often do), but soon learned that such action would not be tolerated in her family.

Debbie was never sheltered because of her condition, but was encouraged to do all she could. It was amazing how she developed a strong devotion to her church at an early age and never wanted to miss attending with her family. When she was four or five, she attended Vacation Bible School with her sister and brother, where they all accepted Christ and wanted to be baptized. At her

parents' request, the pastor said that he would talk to Debbie privately to be certain she understood. After their conversation, the pastor said, "There is no question in my mind that Debbie knows exactly what this is all about and I will, indeed, baptize her." Without a doubt, that same faith helped her to make such progress and helped to strengthen the family unit.

To the astonishment of the doctors who cared for Debbie—and they were numerous—she grew to school age and the Burtons faced another obstacle. She was allowed to enter a public school but, after a few days, school personnel said she was too disruptive in class and could no longer remain in school. A homebound teacher worked with the six-year-old but, while Debbie began to learn the "three Rs," she had no opportunity to learn socially.

At this point, the Burtons and several other parents devised a plan to have the local school system approve the Jenny Ide School, which would give opportunity to children disabled for one reason or another. The school was a success, and Debbie earned an award from the school for a perfect attendance record of six years— despite several critical illnesses that would have altered the lives of many stronger young people. During those school years, Debbie was never a problem but earned the reputation of being able to calm other children when they needed a loving hand.

Because of their determination to help their child and others in similar situations, Felton Burton, always supported by his wife, developed a series of programs for the mentally challenged, a series culminating in what is

now known as Emerald Center in Greenwood, South Carolina, where the family resides. The Center today serves more than 1,000 people with disabilities and special needs in Abbeville, Edgefield, Greenwood, McCormick and Saluda counties.

Debbie has had numerous experiences that she describes as "wonderful." Through his early successful career as Supervisor of License Examiners for the State Department of Highways and Public Transportation's District Two, Felton Burton had made numerous friends in political circles in the state, and Debbie developed a lasting interest in politics.

A visit to the South Carolina State Legislature gave her the opportunity to meet and visit with then-Governor Carroll Campbell, Lieutenant Governor Nick Theodore, several members of the General Assembly whom she knew and admired, among them Senator John Drummond, Representative Marion Carnell, Senator Verne Smith and Senator Billy O'Dell. Burton later made the comment that Debbie had shaken more hands and "worked the crowd" better than he did on that visit. Debbie described it as one of the most exciting things she has ever done.

Knowing the interest Debbie has shown in the Kennedy family at an early age, Senator Drummond and Representative Carnell made contact with Senator Ted Kennedy through Senator Ernest Hollings. They told the senator of Debbie's infatuation with his family and that she knew of his sister, Rose Marie, who had intellectual disabilities. She also knew the Kennedy family had played

a role in establishing Special Olympics. They told the Senator, too, of Debbie's extensive collection of material on his family, which includes more than a hundred videotapes and books about them. Then, in July 2000, Debbie received a surprise package from Senator Kennedy that contained a personal letter and autographed picture of him. Debbie's reaction? She said, "It's like a dream come true!" and immediately wrote a thank-you note that stated the Kennedys are like her own family.

Those who knew her well believe that, under other circumstances, she might have become a leading political leader. And, as successful political leaders do, she wielded a strong influence in the lives she touched.

As it is, Debbie was the catalyst for more important things. Because of her, hundreds of mentally challenged children have opportunities never before available to them. Through their love for her and in their efforts to protect and encourage their daughter, the Burtons have made extraordinary strides in serving people like her. But Felton and Doris are modest people, who have earned the highest respect and admiration of thousands. They are quick to disclaim personal credit for what has been accomplished and give that credit, instead, to God and to the residents of the broad communities their work has served and will continue to serve.

As for Debbie, those who knew her loved her. She has won a place in the hearts of her family and friends and even among strangers. She will long be remembered for the manner in which she "beat all the odds" to become a happy, well-rounded leader among her own.

The Debbie Burton "Making a Difference" Award is presented annually to recognize an executive director or professional who has shown outstanding service on behalf of individuals with disabilities and special needs. For more information, visit www.burtoncenter.org.

ACKNOWLEDGEMENTS

This book has been an amazing culmination of work by people who are dedicated to sharing the positive image of Down syndrome and realize the joy an extra chromosome can bring. Countless individuals have lent their time, talent, and support to help us write this book. There are so many we are not able to name each one, but there are some that we would like to personally acknowledge and thank below. We apologize if we have left anyone out.

Personal Acknowledgements

We couldn't start our long list of thank you notes without looking back over the last few years and acknowledging all of those who helped us navigate this new course our life has taken. Our sincere thanks to:

➢ Raymond's very first nurse in the NICU at St. Joe's who was not going to let her little boy go until she was good and ready -- no matter how much his new foster parents pushed. She made us realize right away how incredibly special this little boy was going to be.

➢ Gay and Melissa the social workers who helped us realize we really were the family meant to adopt

Raymond and fast-tracked us from foster family to adoptive family and led us through every process; and then actually met us in the court room to see adoption day finalized.

➢ Our amazing speech therapist Helen who became our coach, advocate, counselor, friend, and angel for so much more than just developing Raymond's speech.

➢ Tony an amazing physical therapist (PT) who pushed Raymond and us to our limits and was always there to celebrate success in new accomplishments at the end of every session.

➢ Rachel our occupational therapist (OT) who showed us the importance of the little things we do in life contributing to a larger level of success.

➢ Dr. K who while coaching us through the new challenges of a little baby with Down syndrome reminded us he was still a typical little boy with some added challenges. Raymond could not ask for a more dedicated champion.

➢ Ms. Jan and her family who spends every Wednesday with Raymond riding a horse or in the swimming pool. All under the premise of fun and all the while developing muscles that are so crucial to his success.

➢ Ms. Cherie and Ms. Judy you are amazing teachers and created a wonderful foundation for Raymond to excel as he begins school.

➢ And a huge thank you goes to Julie and Melanie who have become much more than respite providers for

Raymond. We are appreciative of your open and loving hearts as well as your incredible patience and dedication.

We owe a debt of gratitude to our parents for their support when we were making the decision to adopt Raymond as well as the support they continue to give us as we raise him and our entire family.

No one can do this alone and when you become part of a local Down syndrome community it is a life enriching experience. We would never have gotten to where we are today without all the special people at Sharing Down Syndrome of Arizona (www.sharingds.org) and the DS Network of Arizona (www.dsnetworkaz.org). We value and appreciate all of the support, education, and friendships we have come to know through these wonderful organizations.

And finally, thanks to our boys Stephen and Mitchell for being such incredible big brothers to Raymond and being so enthusiastic about welcoming him into our family. And to our little Raymond for making such a big entrance into our world and making us smile every day. Because of the three of you, we are incredibly blessed each and every day.

Book Acknowledgements

For all the parents, friends, relatives, and self advocates that caught the vision of our book and sent in stories – thank you. We wished there was a way to share every one of your stories – they are amazing in their own

right and it was an incredible experience to read them all.

Once we had all the materials together, editor Barbara Parus invested an incredible number of hours to give each and every one of these incredible stories a consistent and similar voice without losing the individuality each writer would bring. We started by asking her for a little guidance and she jumped in with both feet fully dedicated to the success of sharing these messages. Thank you Barbara!

Author and book development consultant Sam Horn sat with us when this book was just a budding idea in the back of Stacy's mind. She helped to bring out what this book could and should be and invested a great deal of her time in our success. Thank you just never seems to be enough for the jump start she gave us.

Clint Greenleaf, Lari Bishop, and the creative team at Greenleaf Publishing did an amazing job of taking our thoughts and designing a cover that communicated everything we wanted and more. We are still not sure how they did it, but we are eternally grateful.

The title would never have come about without the research leading to the speech given by Glenna Salsbury when she introduced us to the concept of Windows to the Great Spirit at a monthly Sharing Down Syndrome support meeting. Her speaking created a picture in our minds that we knew we had to share through writing this book.

When it comes to understanding the publishing world, no one is better than Dan Poynter and wealth of knowledge he offers through his book and in person. Thanks to Dan's dedication to seeing us write a book, we shaved months off our learning and development curve.

Another good friend from the speaking world, Susan Roane, has been an incredible inspiration in both giving us a nudge when we needed to keep the book idea moving forward and helping us in determining the best way to share this message of acceptance, inclusion, and celebration.

Michelle Adams and Michelle Freidrich are incredible photographers and captured some amazing and special moments with the photos we used on the cover. Thanks to both of them for their willingness to share these special memories to communicate our message.

The reason these and so many other stories of success and inspiration are possible is because of the parents of children with Down syndrome who had a vision to make the world a better place for our children. We all stand on their shoulders and have realized there are no limitations to what we put our minds to.

And finally we all owe big thank you to all of the doctors, teachers, therapists and specialists who make up the teams that help all parents accomplish amazing things with our children. Your dedication to the success of our kids literally makes all the difference in the world and made so many of these stories possible.

CPSIA information can be obtained at www.ICGtesting.com
Printed in the USA
269871BV00006B/10/P